HOW TO DISCOVER YOUR
PERSONAL
PAINTING STYLE

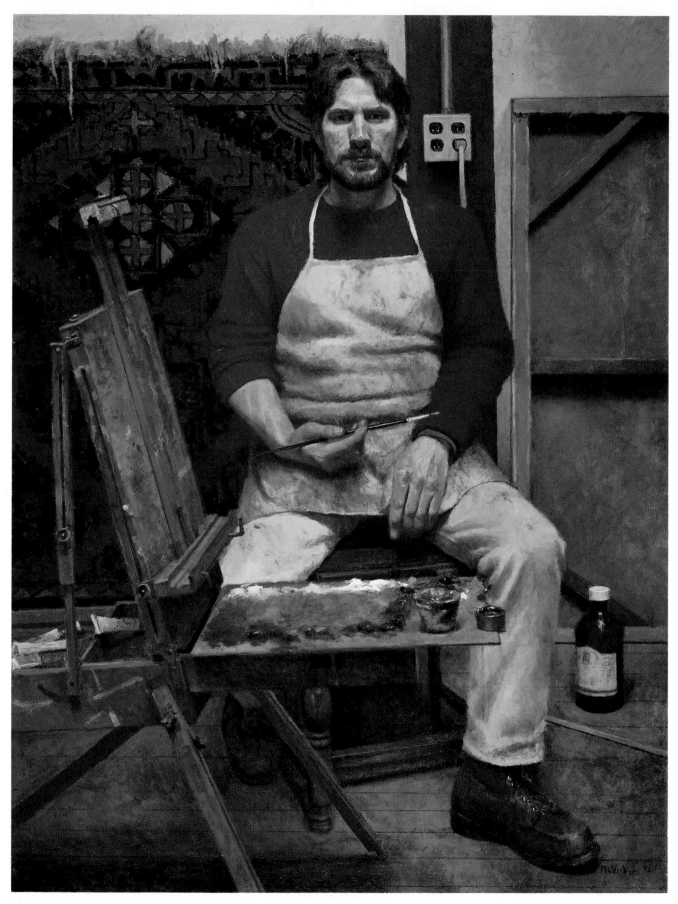

Self-Portrait, Jim McVicker, Oil, 48" × 36", Collection of Mr. and Mrs. Daniel Jacobs.

HOW TO DISCOVER YOUR
Personal
PAINTING STYLE

DAVID P. RICHARDS

NORTH LIGHT BOOKS

Cincinnati, Ohio

About the Author

David P. Richards has been painting in watercolor, oil and acrylic as a professional since 1980. As a teacher, he has helped art students of all developmental levels find their own unique voices through their art. He is a signature member of the American Watercolor Society, the National Watercolor Society, Allied Artists of America, Audubon Artists, and the Pennsylvania Watercolor Society. He has received many national awards, and his work has been shown throughout the United States.

Thanks to each artist for their permission to use interviews and art. All works of art reproduced in this book have been previously copyrighted by the individual artists and cannot be copied or reproduced in any form without their permission.

Cover art by (clockwise from left) Katherine Liu, Edith Roeder, Frank Webb and William Persa.

99 98 97 96 95 5 4 3 2 1

Library of Congress Cataloging-in-Publication Data

Richards, David P.
How to discover your personal painting style / David P. Richards.
 p. cm.
 ISBN 0-89134-593-0
 1. Painting—Technique. I. Title
ND1500.R49 1995
751.4—dc20
 94-41902
 CIP

Edited by Rachel Wolf and Anne Hevener
Designed by Brian Roeth

METRIC CONVERSION CHART

TO CONVERT	TO	MULTIPLY BY
Inches	Centimeters	2.54
Centimeters	Inches	0.4
Feet	Centimeters	30.5
Centimeters	Feet	0.03
Yards	Meters	0.9
Meters	Yards	1.1
Sq. Inches	Sq. Centimeters	6.45
Sq. Centimeters	Sq. Inches	0.16
Sq. Feet	Sq. Meters	0.09
Sq. Meters	Sq. Feet	10.8
Sq. Yards	Sq. Meters	0.8
Sq. Meters	Sq. Yards	1.2
Pounds	Kilograms	0.45
Kilograms	Pounds	2.2
Ounces	Grams	28.4
Grams	Ounces	0.04

This book is dedicated to Pat and Duncan

ACKNOWLEDGMENTS
My grateful thanks to my family and friends who gave me the encouragement and energy necessary for this project.

And, of course, my appreciation and respect for the participating artists who shared their artwork and ideas. Without them, there would be no book.

I would like to thank my editors, Rachel Wolf and Anne Hevener, for their knowledge and editorial assistance and for providing me with the freedom required to pursue my vision of this volume.

Finally, I want to thank Mike Ward, whose ongoing encouragement helped me discover the world of shared "voice" through the written word.

TABLE OF CONTENTS

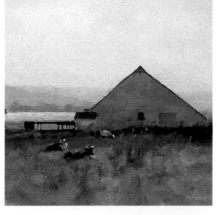

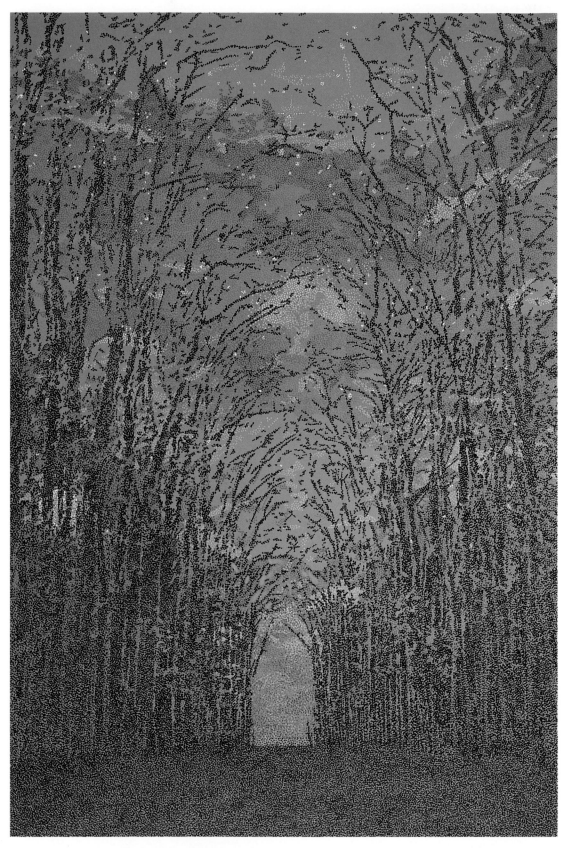

Greensward Hall, David P. Richards, Watercolor, 40" × 27½"
Venturing into the unknown is a part of life and therefore a subject for your art. I wanted to express this sense of moving on with this image of a mysterious, moonlit forest. Every day I pick up a paintbrush is a day in which I take one more step toward discovering what lies beyond the trees.

Finding Your Artistic Voice

"Great art is the outward expression of an inner life in the artist and this inner life will result in his personal vision of the world."

— Edward Hopper

Discovering your artistic identity, your own "voice," is one of life's greatest gifts and challenges. You develop that voice by putting your heart and soul into your artwork every day. Your goal is to share with others how the human experience has shaped your life. When you construct a painting (or a print, drawing or sculpture), you must tap into that experience. Then your art will honestly express your inner being, your picture of yourself, and your personal vision of the world. Your unique artistic voice is an expression unlike anyone else's.

Artistic voice enables us to leave impressions of ourselves on strangers. When you touch pencil or brush to paper or canvas, the act of creation begins. The decisions you make as you pull your medium in one direction and then another culminate in an artistic work that speaks of your fundamental nature, your spirit and your aesthetic sensibilities. You are free to say whatever you choose, to express who you are and who you want to be.

INTERPRETING THE WORLD AROUND YOU

Capturing your identity in your art isn't always easy. You must first back away from what you *see* on the outside, in favor of what you *feel* on the inside. A good painting, after all, requires more than what is seen before you. It's easy to fall into the trap of putting too much of the "actual" into your art and too little of your interpretation. Lack of this point of view robs the work of your unique thoughts on a subject. It may be comfortable to let artistic decisions and choices be dictated by the appearance of a subject, but comfort doesn't make memorable art. The finished work, if you have simply reproduced what you see, will say little about you as an individual. Extract from the real world what you need to express yourself, using that objective reality sparingly.

TAKING RISKS

This path calls for courageous action. Opening up and communicating your innermost thoughts and feelings can be very intimidating. You may be criticized, but if you are sure of your own vision, you can bear up under this scrutiny. And the rewards of recording and sharing your perspectives are exhilarating. Only by taking these risks will you overcome any fear of rejection and the fear that what you have to say won't be good enough to share.

DEDICATED EXPLORATION

It's important to experiment on your artistic journey. Try new mediums. Try new techniques. Express new ideas. Have the courage to move into unfamiliar territory. And give your art the time necessary to make it the satisfying and enriching experience it can be. Expressive art doesn't fall onto the canvas without hard, thoughtful work. It requires personal experiences, solid techniques, and a consciously considered world view. Dedicated exploration will not only improve your expressiveness, it will also improve your craftsmanship. Just as a weekend athlete cannot excel as a professional, artists cannot achieve their peak potential by limiting themselves to painting just one way, only once a week. So, work at art. Participate in this wonderful experience. Don't concern yourself with your present level of expertise. Look to the future, and don't worry about failed attempts. As George Bernard Shaw said, "He who makes no mistakes, makes nothing."

Whether we are interested in sharing the world in which we live or the thoughts we experience, art is a wonderful vehicle to impart our point of view. In this painting, childhood war games become real war and toy soldiers become real soldiers. DePietro speaks of the lessons we are teaching children and asks — in visual terms — if we are doing the right thing. It is a thought-provoking point of view.

Fragment Series: Private Lessons, James DePietro, Oil, 40" × 36"

Developing Your Point of View

Stephen Sondheim's *Sunday in the Park With George*, a play about the artist Georges Seurat, ends with these lines: "Anything you do, let it come from you. Then it will be new. Give us more to see." I put these lines at the beginning of this book because I think they capture so beautifully the creative act of self-expression, the essence of artistic voice.

Art enriches lives. A beautiful painting can stir the soul. A harsh painting can drive home an important social message. A quiet, meditative painting can transport a viewer to tranquility. A whimsical painting can emphasize the healing power of humor. But first and foremost, art is a reflection of a most personal nature — it is an expression of the artist who creates it. The great variety of subjects, mediums and techniques invites us to participate in something that is of ourselves and something that will share our humanity with others. To participate we must impart our point of view.

THE HEART OF CREATION

When I first conceptualized this book and began to organize the information it would include, I planned to begin with a series of quick instructional guides on use of the basics. Topics such as line, value and color seemed a logical place to start because these are the tools we use to create a painting—the instruments of self-expression.

But after working on the text for several months, it occurred to me that I should reconsider the progression of subjects. It struck me that a chapter on the artist's point of view would be the best place to begin. After all, what is the most important aspect of the creative act? The answer is powerfully obvious: a well-conceived vision of who and what you are. Vision is the springboard to any great work of art; it is all-important. Without it, there is no need to proceed.

Knowing What You Want to Say

Knowing what you want to say is the first step. From this starting point you can push an idea out onto a canvas through the use of different mediums and technique. The technical aspect is, of course, very important. It provides the means by which you convey your concept. But an artist's use of art elements must support his or her point of view, not the other way around. Technique continually develops and improves with practice. Even when perfected, technique cannot make a vapid subject great art.

However, art history is full of examples of exceptional personal expressions that transcend the confines of technical perfection. Many great artists have exhibited technical proficiency early in their careers, but then moved on to emphasize point of view. Think of the work of Jackson Pollock, Pablo Picasso, Henri Matisse, and Vincent van Gogh. Their early work, while technically proficient, was unlike their later, more passionate work.

An Ideal Synthesis

Ideally, an artist can attain a synthesis of technical proficiency and personal statement. "What" and "how" coalesce into a finished work that stands as a representation of you, the artist. The work makes a statement unlike anyone else's. So, you must examine how to use the art basics to convey this illustration of your thoughts.

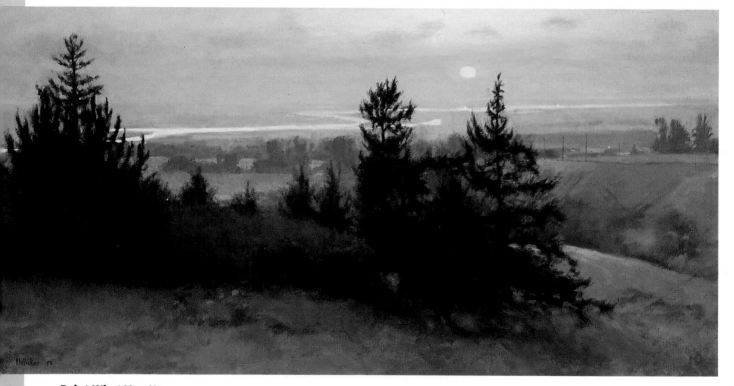

Paint What You Know

We are what we paint—or we should be. The old adage "Paint what you know" is wise because it leads to honest and clear expression. One subject that McVicker knows is the land around his California home. His love and respect for this subject radiate from beneath the surface of the paint.

Sunset—Eel River Valley, Jim McVicker, Oil, 24" × 48", Private Collection

The Seeds of Thought

Concepts come to life in our minds. Here the seeds of thought grow into carefully developed ideas that become our purpose for painting. Although I don't understand the physiological process that connects our gray matter to a finished work of art, in my imagination I see it as a simple course that lets ideas flow from our brains to our hands. By this miracle, our thoughts pass outward from within to become tangible, visible expressions. The resulting objects, the pieces of art, survive us as statements that we were here.

Focus on Design

A focus on pure aesthetic design is all-important for Webb. In his art, concept, process and composition take precedence over theme and subject. Webb believes "achievement is more pertinent than success."

Ferry at Oban
Frank Webb
Watercolor
15" × 22"

Visually Speaking

Our painting should speak of our own special place. Meditative thoughts and reactions put into visual terms are reason enough for a work of art to exist. In this painting, Liu presents the spiritual essence of an object and word that sparks the imagination of her audience.

Visceral Map #2 , Katherine Chang Liu
Mixed mediums, 40" × 27"

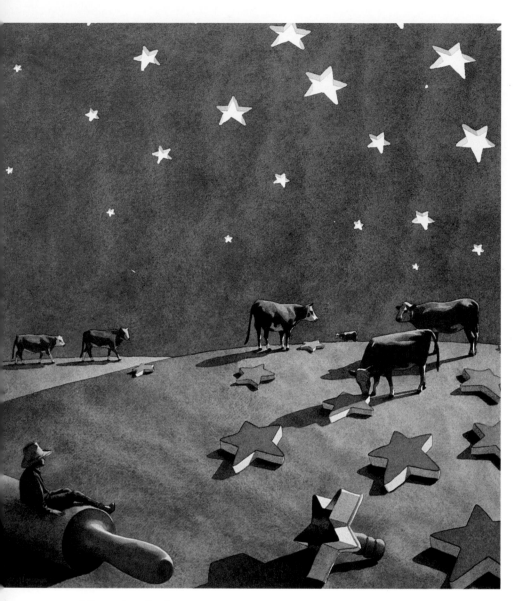

Adding a Touch of Humor
Any topic, theme or approach is fair game in art. Moore regularly employs an adult eye to draw inspiration from childhood experiences. Adding humorous interest through the use of synonyms, colloquialisms and puns, he presents a world of wit and serenity.

Star Grazing, Scott Moore, Watercolor
23" × 21¼", Private Collection

ARTICULATE YOUR GOALS

A clear and confident realization of point of view for a developing piece of art is my battle call, both personally as an artist and as an art teacher. We are often told that all we have to do to succeed is to know what we want—as if this knowing were an easy task. Articulating your goals to yourself can be difficult, but it is essential. If you can envision something in your mind, you can work to paint it. It takes conscious effort to define and understand your hopes and desires. Self-actualization develops in degrees over time and can only be attained if you know what you want to accomplish. The quest for self-actualization, artistically and personally, is worthwhile.

What Does It Mean?

I vividly recall a day early in my teaching when, as so often happens, I, the teacher, had the learning experience. A student had just finished a painting he had been working on for some time. We were discussing the work. The student's focus was purely on technique; he spoke of how he had painted this area and that. His self-critique centered on the technical aspects of the work.

In viewing the work, I was confused by the meaning of some of the objects in the design and asked why they had been included. My question, "What are you saying in this painting?" was met by a startled stare. The student was unable to respond in a coherent way that would help me understand. What was surprising to both of us was that the question had never come up before. Neither of us had asked it as the work was progressing. The student had been more concerned with technical proficiency than with a clearly articulated concept. Of course, he knew subconsciously

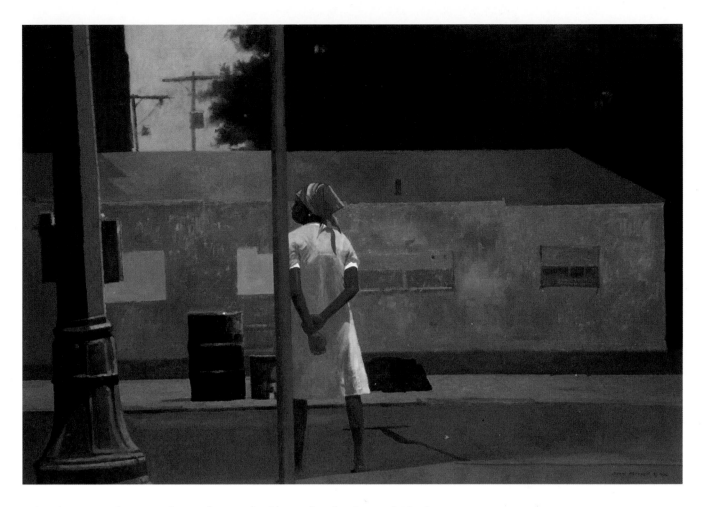

what he wanted to say about the subject, but he had used symbols so personal that they were meaningful only to him. The painting would have benefited in its attempt to convey meaning to others by a better defined concept and a well-articulated purpose. You must always consider your audience.

Communicating Your Thoughts

To communicate your thoughts visually — and to make good art — you must develop technical proficiency. A baby doesn't think about speaking pearls of wisdom before it tries to talk. She must master the vocabulary before she can communicate her thoughts. Eventually, for all of us, mimicry gives way to personal expression. Having learned the labels, we apply them to the concepts we choose to express.

The student mentioned above had been developing technical proficiency, mastering the tools of expression, but had unknowingly reached a point in his development at which the viewer no longer had to struggle to discern form. Form was proficiently conveyed in this student's work, but his thoughts were not — the words were being pronounced properly, but the message was unintelligible. The emphasis had to shift from technical form to the articulation of concept. That was why my question, "What does it mean?" came as such a surprise. Up to that point, the student's goal for his art was to master technique, and I had worked with him to achieve that goal. But the time had come when technique was not enough, when the "why" demanded more of this artist than the "how." The time had come to stop imitating and start creating.

A Social Point of View

Mitchell's social point of view makes a statement about life in the inner city based on the concepts of street smarts and survival. His art lets him explore a full range of issues and images that speak to the human experience and share them with the viewer.

Bright Gesture, Dean Mitchell, Oil, 30" × 40"

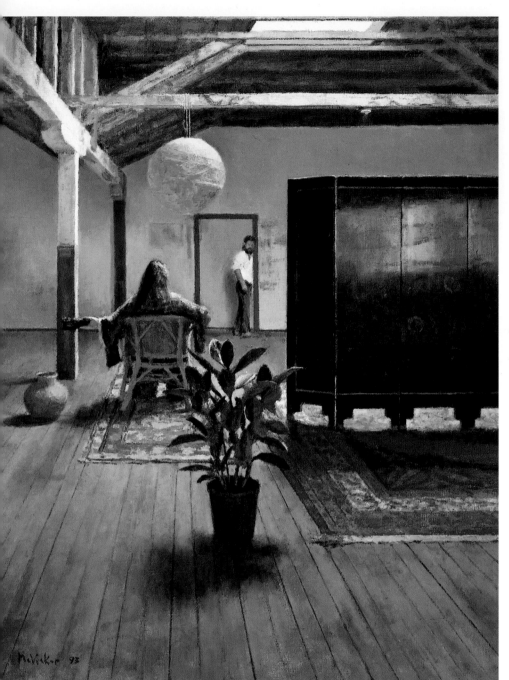

Storytelling

A painting can be allegorical. *The Last Song* relates a story that unfolds as we watch from an isolated viewpoint. McVicker is the storyteller; we are the listeners.

The Last Song, Jim McVicker, Oil, 23″ × 18″
Collection of the Artist

YOU ARE WHAT YOU PAINT

Socrates once said, "Know thyself." How does this apply to making art? Well, almost always, the best art is about yourself. Painting what you know, painting what you are, is the way to achieve successful and satisfying self-expression. When you try to force something that is not an honest expression of your inner self, it will not ring true. Even artists who have their subject matter dictated to them are successful only when they interpret that subject through their own perceptions. That is what makes a Michelangelo or a da Vinci so stunning. That is what distinguishes a Sargent or an Eakins from thousands of forgettable portraits. Your insights should inform your art.

A Journal of Thoughts and Feelings

Art is a wonderful way to communicate aspects of your nature that may be difficult to exhibit in other ways. Images of who you are becoming or would like to be can be important subjects. They become a sort of symbolic self-portrait. Sharing your private self is easier when you portray it in a form that represents but is physically separated from you.

I like to think of my art as a daily journal of my thoughts and feelings. It's a barometer of my emotional and intellectual life from day to day, event to event, painting to painting. When I look back at the body of work I have produced over the years, I recall who I was and what I experienced. I also keep a written journal of ideas for future paintings that helps me prioritize and clarify what I will work on.

THE PITFALL OF IMITATING OTHERS

Imitating artists we admire is a rite of passage on the road to self-

expression, but then each of us must find our own way. This seems a rather obvious thing to say, but often artists work too hard to copy the style and subjects of an artist whose work they admire. Imitation is a natural stage in your development as an artist, but if you continue to imitate, the work you create will say little about you.

Listen to Your Own Voice

Discomfort with your own voice is something you and every other artist will experience to some extent. This is true even of the speaking voice. I remember how disconcerting it was to hear a tape recording of my voice for the first time, how unsettling and for some reason embarrassing. After a few more experiences with tape recorders, I overcame the discomfort and focused on the purpose of the recorded message rather than the sound of it. So it is with our art. The first time we show our work to others, not to mention the first time we enter our work in a juried exhibition, may be an uncomfortable experience. But trying to avoid this self-exposure is unhealthy for us as artists. And imitation only invites comparison rather than deflecting scrutiny.

A Variety of World Views

Variety *is* the spice of life, and each artist has a unique perspective to communicate. If all the artists of the world were collected together into one huge room and asked to paint the scene before them, there would be as many interpretations of that scene as there were artists. Art should interpret life, not imitate it. The life forces that have shaped you will shape your art, provided you let them. Remind yourself that there are *many* world views, not right ones and wrong

Addressing an Issue That Concerns You
Environmental and ecological issues that address the world we will leave to future generations find expression in the art of DePietro. An uninhabitable world of mounting trash and disappearing land is a compelling subject for the art of our time.

Trash Series: #89 American Pops
James DePietro, Oil, 40" × 46"
Collection of Richard Begbie

ones, and each view has worth. No one grows without the influence of others. In fact, learning from the experiences of others can actually hasten your development. Focus on using those influences to journey to your own special place, to progress and flourish.

When you see a work that strikes a chord, analyze the painting for helpful hints that will ultimately foster your own clarity of expression. But imitate only sparingly, or you risk sacrificing your own artistic identity.

ART IS COMMUNICATION

Each of us has our own reason for painting. As a reflection of yourself, any subject, topic, theme or approach is fair game. You may paint objects or ideas, themes rooted in humor, morality, politics, patriotism, religious or social convictions, sensuality, dreams or nightmares. Here again, a sense of self will be the guide. You paint what and who you are, or what and who you want to be. Your canvas stands as a window on your experiences. But personal experiences become art only when they become accessible to others. Art must communicate.

Consider Your Audience

Communication implies a message sent, received and responded to. The true challenge is to speak objectively about subjective experiences. Emotion becomes art through the distance of recollection and reflection. By considering your personal experiences and relating them to the larger human experience, you make art communicative and aid the viewer in accessing that experience. Commonplace themes remain commonplace until you interpret them through your voice.

Speak from a narrator's perspective to gain the distance you need to interpret what you want to say. This can help you step beyond your experiences in order to make sense of them as a part of a whole, for the personal should become universal. If we can't communicate our ideas so that an audience can perceive and appreciate them, our expression has failed. If we are too subjective in our symbolism or imagery, we place the entire burden of finding meaning on the viewer, who may misinterpret our message.

Offering a Fresh Look

Art can exist for art's sake. Luhman's aesthetic composition is designed purely to delight, focusing primarily on the sensation of pure color and abstract pattern. We are simply seeing something familiar in a new way.

Stripes 1, Denise Luhman
Acrylic and oil, 9" × 12"

Fireflies on a Grid
David P. Richards
Acrylic
19½" × 18¼"

Communicating a Concept

Your art can be the visualization of an idea based on pure concept. My acrylic glazing *Fireflies on a Grid* was inspired by my consideration of the makeup of color and light and expresses that wonder through artistic imagination.

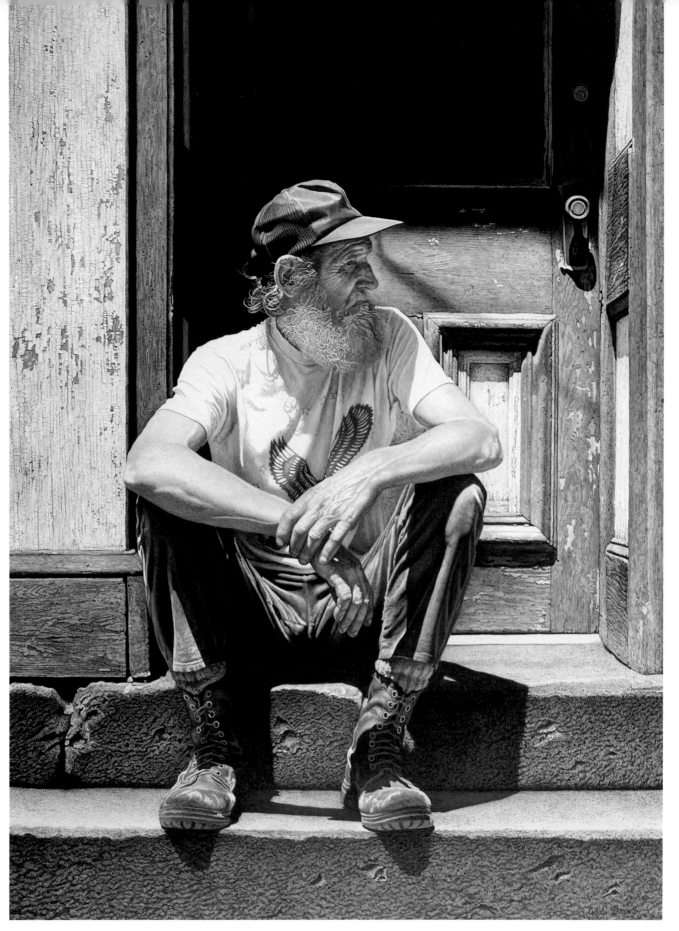

Recording a Life
Portrait painting is special because it not only projects the artist's point of view of the sitter, it also says something about the sitter's reactions to life and the world in which he lives.

Reds, Douglas Wiltraut, Egg tempera
57" × 40", Collection of Mr. and Mrs.
Norman Kobrovsky

A UNIFIED BODY OF WORK

When I first received the slides from the artists whose work illustrates this book, I was struck by how many of them work in the series format. Painting multiple works that are connected by a common thread gives these artists the opportunity to explore a subject in depth. A collection of works presents a wider, fuller scope of a subject than one individual piece can.

This approach of developing and illustrating a theme from more than one perspective appeals to a great many artistic minds.

Preserving a Place

One of the most powerful examples of the series approach is Charlene Engel's work on Thomas Pond. She has spent two decades preserving images of this beautiful location in Maine. Getting to know the place intimately, she has painted almost every cove and corner of the pond.

Within her continuing theme, there is enormous variety as she captures individual pieces of the ever-changing whole. This career-long representation of a single subject allows her to address the issue of vanishing nature, as she watches this beautiful region change and, in places, disappear.

Big Rocks, Bass Bay, Charlene Engel, Watercolor, 15" × 22"

Thomas Pond—October, Charlene Engel, Watercolor, 22" × 30"

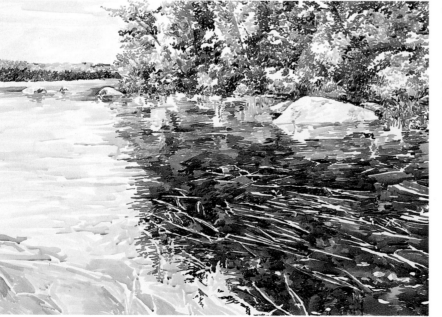

PHOTOGRAPHY OF CHARLENE ENGEL'S ART BY LEN ROTHMAN.

Bass Country, Charlene Engel, Sepia, 22" × 30"

Capturing the Spirit of a Place

Near the end of his life, the Impressionist master Camille Pissarro remarked to his son, Lucien, that if he could have his life to do over, he would stay in one place for twenty-five years. In this way, he could really know that place well, capturing in his art the endless variety that is the essence of the place.

This sentiment is shared by Engel, who has returned to paint Thomas Pond, Maine, for the past two decades. Capturing the spirit of place, these paintings provide a record of the artist as well as her subject—a record of what is and what was.

Raymond Marsh
Sebago Lake
Charlene Engel
Watercolor
22" × 30"

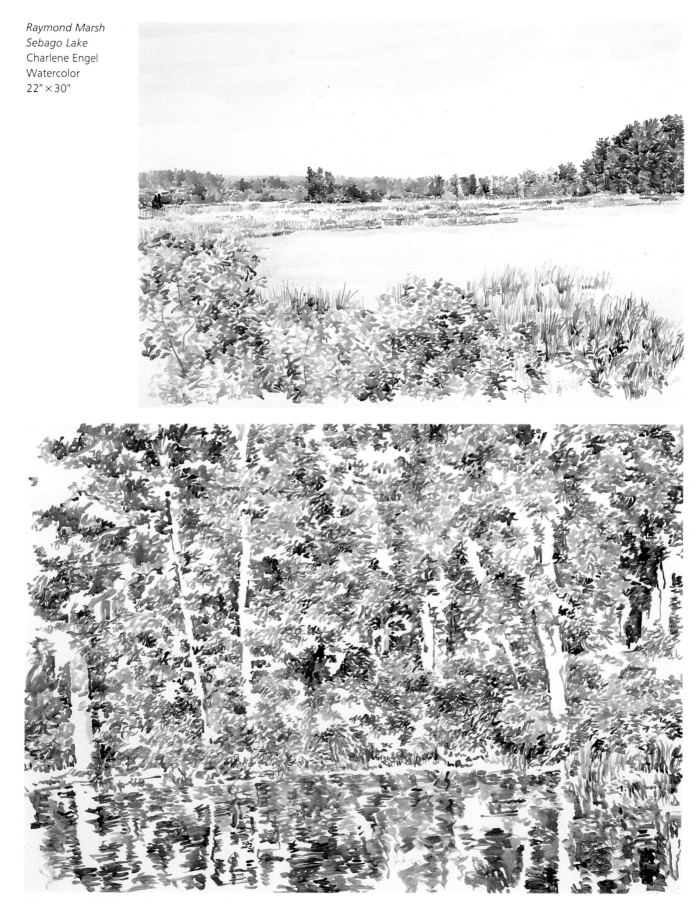

Thomas Pond 1992, Charlene Engel, Acrylic, 22" × 30"

An Architectural Impression

William D. Gorman also uses the series format to capture the essence of place. His viewpoint is the spiritual experience he feels when visiting a particular location. He generally focuses on illustrating the architectural impressions, preferably of a bygone age in a region. He works up a substantial number of expressions and emotions. He does not include as many works in a series as Engel does. Nonetheless, the multiple images are necessary for him to complete his vision. When he feels he has achieved his goal for representing a particular place, he moves on to another place and another series.

Making Statements

James DePietro has also painted a series of series. In his case, no unifying feature connects one series to the next. But within a specific grouping of works, a unified concept is obvious. DePietro generally completes eight to twelve paintings before moving on to a new topic. DePietro enjoys this approach because it gives him many opportunities to say all he wants to say on the topic and from a number of diverse yet related viewpoints. One such grouping is his Trash Series, in which he portrays an ecology-oriented theme in twelve distinct images (see painting on page 9).

The Evolution of a Series

Daniel E. Greene presents a stunning series of works based on a concept that evolved from an idea for one painting. New York City subway stations had long fascinated Greene. In 1989, when he descended from the street into this subterranean world, he envisioned a series to capture the range of images. He dedicated three years to this project, which culminated in more than two dozen works.

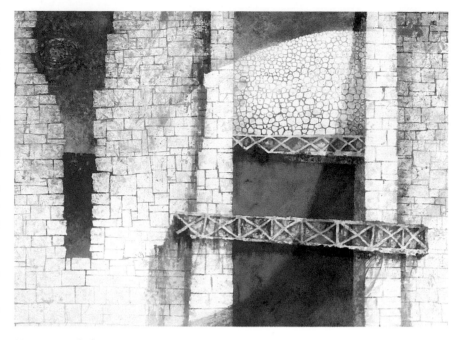

Newgrange Series: Entrance
William D. Gorman, Casein, 22″ × 30″

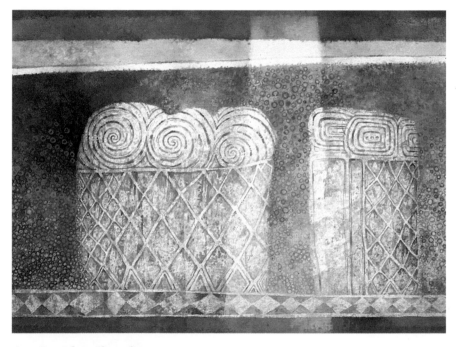

One Complete Thought
Gorman, like Engel, uses a series format to express his impressions of a locale. Like sentences in a paragraph, the collection of work adds up to one complete thought. After he feels he has satisfactorily represented his subject, Gorman moves on to another series, another place.

Newgrange Series: Kerbstones
William D. Gorman, Casein, 22″ × 30″

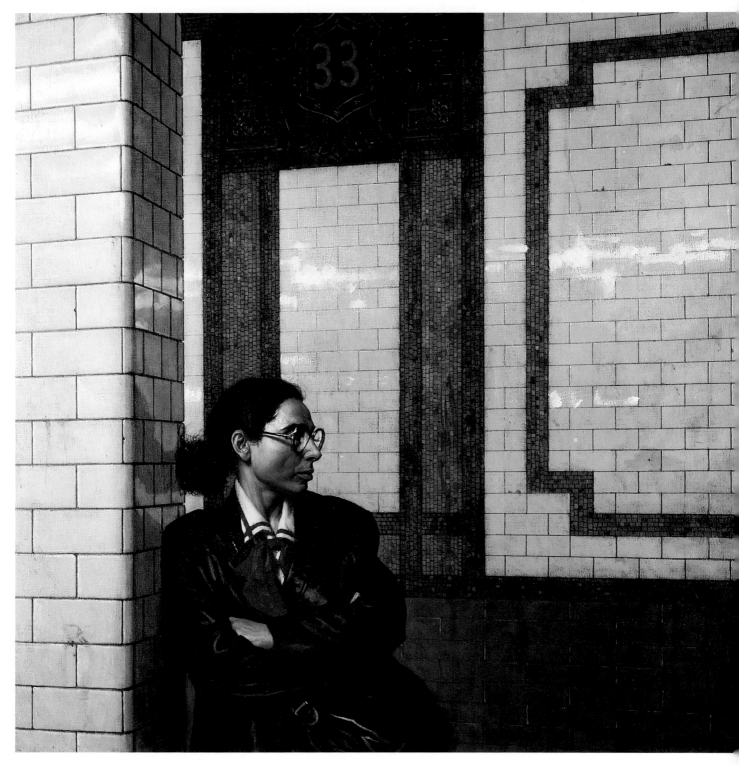

Seeing the Possibilities

One painting can lead us to see possibilities for future works. For Greene, what began as a single painting designed to capture the mosaic embellishment in the New York City subway stations turned into more than two dozen works. Descending into the environment with its many inhabitants, he saw so many images he wanted to capture that he knew right away he was dealing with a series.

Ana — 33rd Street, Daniel E. Greene, Oil 46" × 46", Courtesy of Gallery Henoch

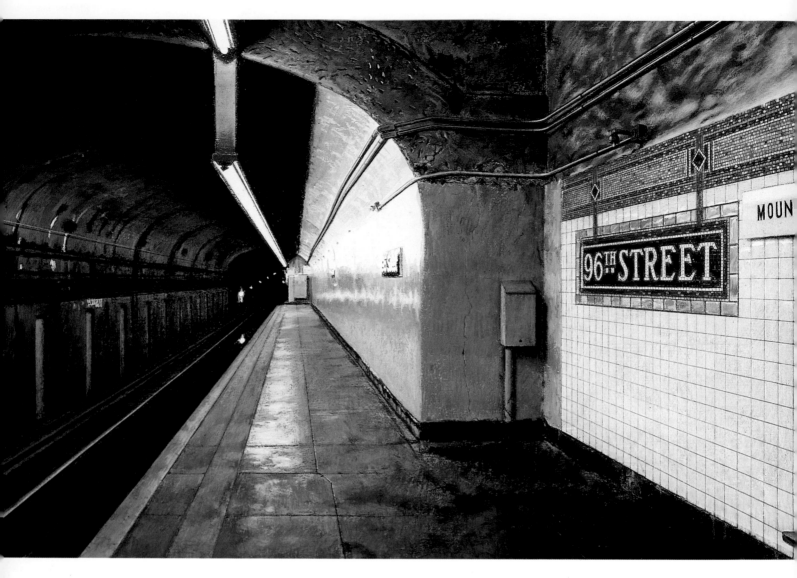

Since his earliest days in New York, Greene was struck with the beauty of the mosaic embellishment of the otherwise dreary subway stops. In 1989, after trips to Pompei and the Vatican, where he was moved by the extraordinary beauty of the mosaics there, he acted on his long-held inspiration to capture this urban beauty.

96th Street Tunnel, Daniel E. Greene
Pastel, 40" × 60"
Courtesy of Gallery Henoch

A Mind of Work

As I looked at the works of the participating artists, I saw more and more connections that revealed a series: Earl Grenville Killeen's door paintings, Jane Conneen's illustrations of herbs, Pat San Soucie's abstract quilts, David Reinbold's portraits of his wife. Even my own work contained a collection of design-oriented garden and landscape paintings.

When I was viewing the splendid, but seemingly unrelated cityscapes and portraits of Irwin Greenberg, I began to see how the pieces were connected through their depiction of the human condition of the city. Then the realization struck me. All of these individual pieces were a part of a whole. These artists were working in series. The focus may be tight, as in Engel's approach, or subtle like the loose interwoven thread in Greenberg's pieces, but the body of work is all tied together by the perspective of the artist who created it, even those works that may at first glance seem unrelated.

Consider the work of Judi Betts, whose paintings project her joyful philosophy of life, or the work of Scott Moore, whose unique humor is a unifying factor in his work. Perhaps we shouldn't call it a body of work, but rather a mind of work. It is the unique insight of one artist interpreting the world.

Eighty-Sixth Street, Irwin Greenberg
Watercolor, 5½" × 14"

Connecting Themes

Juxtaposing groups of people against the massive architectural structures of the city has been an ongoing theme for Greenberg. These paintings are connected in that they express the fragile human condition, emphasized by the figures in relationship to the inner city buildings. The paintings are also connected, however, because they reflect the point of view, attitude and sensibilities of their creator.

Beaux Arts, Irwin Greenberg
Watercolor, 7" × 11"
Courtesy of Wyckoff Gallery

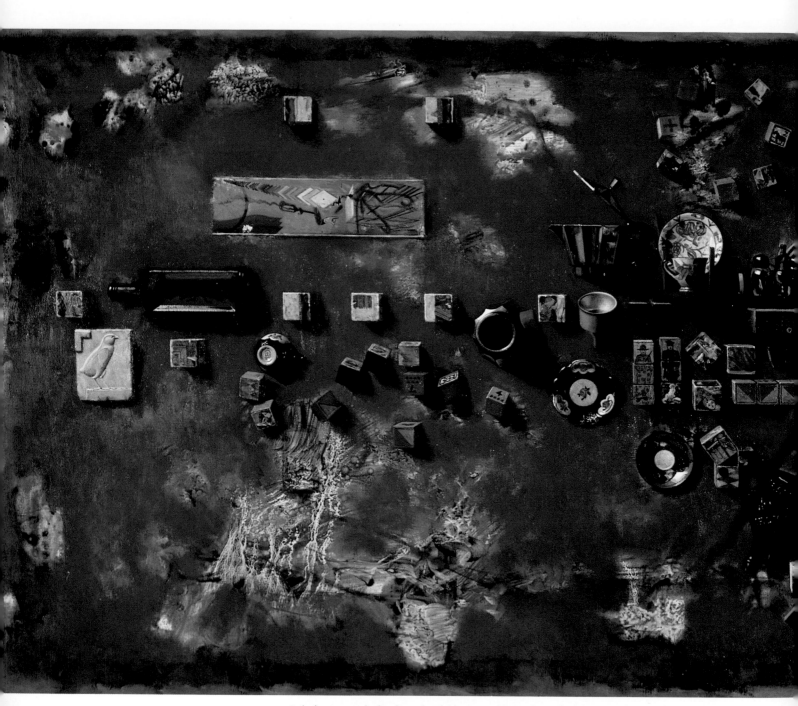

A desire to speak clearly and quickly on a wider variety of subjects can be satisfied through the study of examples found in our artistic heritage. Greene offers this advice on the topic: ''I certainly would recommend to aspiring artists that they steep themselves in what is happening and what has happened through the centuries.'' While this painting is a completely original work, its concept and composition were influenced by the artistic vision of nineteenth century painter Marcel Duchamp.

Duchamp and Blocks, Daniel E. Greene, Oil, 48" × 80", Collection of the Artist

A Starting Point for Self-Expression

A working knowledge of the fundamental components of visual art, such as line, value, color and design will give you a solid foundation on which to build your artistic voice. This is the starting point of self-expression, not self-expression itself, but as the saying goes, a journey of a thousand miles begins with the first step. By understanding some of the unlimited possibilities of these elements and their subsequent relationships, you can skillfully manipulate them to better express your point of view.

A wealth of information and ideas has been handed down to us over the years — concepts and techniques that have been explored, tested and proved effective. This is your aesthetic heritage, and it connects you with artists of the past. How the generation of artists that preceded you worked will affect how you work, just as the generation before them influenced their art. This accumulated experience, which has translated basic elements into creative tools, is available to you through study. It will speed you on your way and provide the springboard from which you can leap toward freedom. If you don't take advantage of this body of basic information, if you don't expose yourself to it continuously in your creative endeavors, you may find your voice more restricted than you wish it to be. It is never too late to learn from your aesthetic heritage.

THE ARTISTIC VOCABULARY

Your desire to speak faster, more fluently and on a wider array of topics can be fulfilled through strong artistic vocabulary training. In the case of self-expression, *what* you are going to say will often determine *how* you say it. You can paint whatever you can visualize or conceptualize in your mind, but you must have knowledge to do it successfully. For example, when Judi Betts wanted to express feelings of sunshine and joy in the painting *Pier Pressure*, she drew on her knowledge of value and color. A strong foundation in this area helped her achieve her goal. Likewise, Richard Hamwi's use of line communicates a sense of movement and energy. It is the way he uses line that transmits this feeling in his painting *Eruption*.

The following four chapters ex-

Speaking Through Color and Value
Betts's images capture the feeling of sunlight and project an optimism based on hope and happiness. Her extensive color knowledge helps her succeed in passing this optimism on to others through her art.

Pier Pressure, Judi Betts, Watercolor, 22" × 30", Collection of Dr. and Mrs. Marvin Rothenberg

Eruption
Richard Hamwi
Watercolor collage
15" × 22"

The Power of Line
It isn't luck or guesswork that Hamwi depends on to create his exciting images of energy and movement; it's a strong core of knowledge that continues to grow with each successive work. The power of the line he employs in *Eruption*, both static and active, works to pull us into the painting and then sweeps us away.

amine some of the basic truths about line, value, color and design. I say "some" because whole volumes have been written on each of these topics, and I highly recommend that you do additional reading and study. In the space available to me in this book, I will present a series of quick guides covering information that I hope you'll find helpful and interesting.

BUILDING PHRASES

The basic elements cooperate with one another to become a work of art. Interactions between the ingredients—value, color, line, texture, brush technique, balance, perspective—all synthesize into one piece of work. It is this gestalt, the whole versus the parts, that will have an impact on the viewer.

So it is important to build experience in all of these areas, focusing at first on each separately, and then in conjunction with one another. Experience is the key. Practice, read, practice, combine, practice, express. Color work that ignores value won't help your painting.

Likewise value must be considered in terms of its placement in a composition. You must use these tools in combination. This is the most powerful argument for developing a strong working knowledge of all the basics. You may have a natural sense of color, but even an innate talent like this requires support to be used most effectively. Starting with the individual components and adding them together in informed combinations will best enable you to tell your tale.

◀ *Untitled,*
Michael Kessler
Acrylic, 80″ × 48″

Black and Fuchsia
Denise Luhman
Acrylic and oil
24″ × 20″

Building on the Basics
Whether you choose to communicate your ideas in a figurative way or in a more abstract or nonobjective manner (as seen in these two works), a strong working vocabulary in the basics of art—line, value, color and design—will help you to achieve your goals.

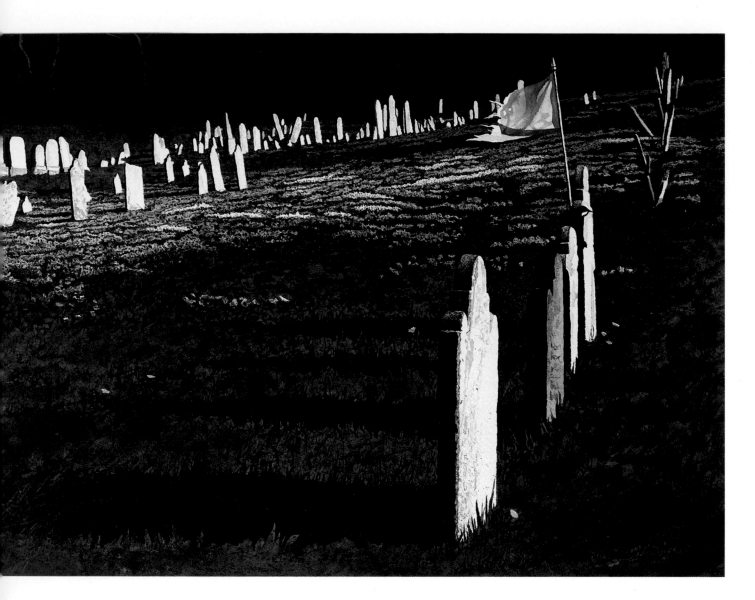

To construct a body of powerful images, innate and intuitive talent must be supplemented with core knowledge and practiced implementation.

Heaven on Earth, Douglas Wiltraut
Watercolor, 21" × 29"
Collection of Dr. and Mrs. Steven Diamond

THE INTUITIVE ARTIST

Stories abound about artists who walk into an art supply store, buy five tubes of paint (red, yellow, blue, black and white), a brush and a canvas, and then go home to paint a masterpiece. These anecdotes— some perhaps even true—describe exceptions to the rule; they do not portray reality. The rule is that good art is solidly based in form. While your first paintings may be promising enough to encourage a continued effort, a successful body of work is built on acquired knowledge and hard work rather than intuition and accident. It cannot be denied, however, that innate ability is a powerful factor. A natural sense of color or a talent at arranging dramatic compositions is a powerful strength to build on and may be what drew you to art in the first place.

To improvise effectively, a musician must first know chords, scales, and a great deal about the instrument. The same is true of the visual artist. Use your intuitive ability to its fullest advantage by increasing and enlarging it. The intuitive must become conscious. Reflect on what occurred and why; this will help you re-create the effect or alter it as you desire. Analyzing the automatic and making the intuitive explicit will help you grow and establish something really dynamic.

The accumulation of this working knowledge isn't necessarily the fun part of creating. But it is important homework. Learning can be enjoyable if approached with a positive attitude. The faster you can acquire the tools of your trade, the faster you can move on to the creative part of it. And the more you know, the more you can accomplish.

AN ACT OF FAITH

Paradoxically, once you have studied and practiced and built up that foundation of knowledge, you must internalize it to the point of making it part of your subconscious, part of your intuition. Pushing it into the background in favor of personal feelings and unique expression is critical to the developmental process of creating.

Knowledge and practice pay off in performance. What you've learned will not let you down. The human mind is an amazing phenomenon, able to retrieve from the subconscious whatever you require. The more you work, the more you use your knowledge, the less you have to think consciously about what you do. You will be able to make judgments automatically. The musician I spoke of a moment ago will not have time during the performance to analyze his technique. It must be second nature, automatic. The fingers must respond spontaneously. Otherwise, his improvised expression will become cumbersome. The same is true with your art. Let it happen. Many of your choices will subsequently seem like obvious decisions based on intuition and common sense. But there is always reason behind what you do. Common sense in art is an outgrowth of education and experience.

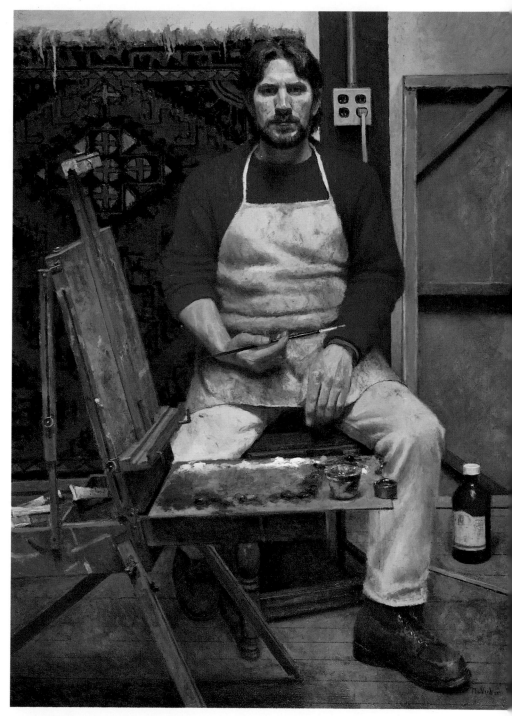

Intuition Grows Out of Experience

Every painting we make is in some way a self-portrait. The artist within all of us can express any idea through the process of creating images. If you can visualize something, there is a way to illustrate it. Each time you approach your easel, the knowledge that you have worked to acquire through the years will pay off in performance and the finished communication.

Self Portrait, Jim McVicker, Oil, 48" × 36"
Collection of Mr. and Mrs. Daniel Jacobs

A Quick Guide to the Vocabulary of Line

On a recent trip to France, I was fortunate enough to see some of the cave drawings from Lascaux. These renderings, some of man's earliest, represent the dawn of artistic expression and yet remain to this day some of the most thrilling examples of the power of line. My first reaction to these markings was awe at the history they represent. My second reaction, that of an artist, was awe at the artistic sophistication they project. Fifteen thousand years ago, humans, in their first attempts to capture and hold fast the likeness of something important to their daily life and experience, somehow understood that the tool of line, simple and direct, could be manipulated to distinguish between a huge bison and a graceful deer. Just by controlling and altering the tension, the pressure and the direction of line, they could depict and record for all time the variety of their surroundings.

We, too, have this power. When we touch a pencil or some other instrument to a surface, we create the simplest of marks and begin to define our space and what is important about ourselves and our world, just as our early ancestors did.

A "simple" line can be admired for its purity. In *Beach in Cannes*, Hollerbach utilizes this appreciation to establish an image that is as powerful and appealing as any intricately rendered painting.

Beach in Cannes, Serge Hollerbach, Ink and brown wash, 8½" × 6½"

THE CHARACTER OF LINE

A pencil meets paper in the simplest of marks—a point. When you pull that point across a surface it leaves a path behind it as it goes. This path, this line is as limitless in character as an artist's imagination.

Every line, like every artist, has a unique nature. Do you want your line to enhance your expression by singing or shouting, by dancing delicately across the page or lumbering heavily, or by sitting still in a gesture of power and permanence? Do you want to speak to your audience briskly or warmly? What do you want to say? How will you say it? Every mark you make will affect what your art communicates.

SHORT LONG FIRM WAVERING SMOOTH JAGGED PALE DARK ANGULAR STRAIGHT

The Character of Line (left)
The character of a line is almost as varied as what we can illustrate with it. A line can be of any length, any width or in any configuration and can move in any direction, including right out of the picture plane.

Ancestral "Line"-age
This small monoprint tribute to Paleolithic man's cave renderings pays homage to his ability to manipulate the most basic art element in a way that successfully illustrates a great variety of objects and surfaces.

Lascaux Impressions, David P. Richards
Crayon and sandpaper monoprint, 6" × 8"

Doodle's Doodle, Patricia O. Richards
Marker, 15" × 11"

Expressive Power of Line
Line can embody graceful movement or sit imposingly in a gesture of power. The swirling and playful *Doodle's Doodle* (above) by Patricia O. Richards is in complete contrast to my illustration (above left) of a bold line that seriously commands the viewer's attention.

Spring Still Life (far left)
Anne Bagby, Watercolor, 36" × 24"

Communicating an Impression
The overall impression of Bagby's *Spring Still Life* is one of lyric beauty. This is due in part to her use of delicate line. It weaves and intertwines into a rich decorative surface that communicates her feelings of joy and celebration. The detail helps us understand the complexity that creates this effect.

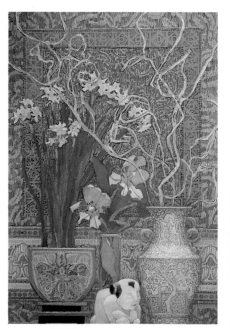

THE EMOTIONAL POWER OF LINE

A line may be any length, from the simple dot to an extension that expands and pulls us right off the page. Line has the power to move the eye up or down, left or right, to stop us cold, or to combine with other lines to focus our attention in one particular area. Line can be straight and rigid or flowing and free. If it should change direction, it can do so in a smooth curve or in a sudden abruptly angular way. It can be firm or graceful, meander along or dart about in a high-energy zigzag. Line can magically change its width or remain constant, have a smooth edge or a jagged edge, be soft and pale or dark and strong, or gradate from pale to dark within one stroke.

All of these various marks project specific moods, and this variety is at your disposal. With it, you can set your viewers on the edge of their seats or invite them to lean back and kick off their shoes.

Different directional pulls create different physical and emotional responses. The chart that depicts the characters of line shows different forms of line, from the most passive horizontal to the dynamic spiral, and their most commonly evoked responses. You can work these lines and their derived shapes into any composition to achieve the effect you want.

HORIZONTAL LINE: MOST PASSIVE. CALM. RESTFUL. PEACEFUL. RECLINING. LACKING MOVEMENT.

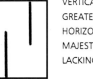
VERTICAL LINE: GREATER ENERGY THAN HORIZONTAL. POISE. MAJESTY. DIGNITY. LACKING MOVEMENT.

DIAGONAL LINE: INCREASED ENERGY AND TENSION OVER HORIZONTAL OR VERTICAL. PROJECTS MOVEMENT AND SPEED. BECAUSE WE READ IN A LEFT TO RIGHT DIRECTION, LINES THAT PULL US FROM LEFT TO RIGHT CAUSE LESS TENSION THAN A RIGHT TO LEFT PULL.

FLOWING LINE: RHYTHMIC. CALM. FEELING OF CONTINUITY. SWEEPING MOVEMENT.

ZIGZAG LINE: EXCITEMENT. ANIMATION. CONSTANT MOTION. AGITATION.

SPRAY: LIGHTHEARTED. RHYTHMIC. GRACEFUL.

POINTILLISM OR STATIC PATTERN: CALM. RHYTHMIC INTERVALS.

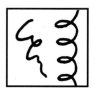
BROKEN, FRAGMENTED LINE: ELEVATED ENERGY. NERVOUS. EXCITED. FORCE.

SPIRAL, TWISTED LINE: HIGH ENERGY. CONFLICT. RHYTHMIC. RHYTHMIC AND GRACEFUL IF CONTROLLED.

CONVERGING LINE: POINT TO CENTER OF FOCUS.

ROUNDED FORM: GRACEFUL. CALM.

ANGULAR FORM: EXCITED.

COMBINATION OF UNDULATING AND RIGID FORMS: INCREASES ENERGY.

SIMILAR SURFACE TEXTURES: PROJECTS CALM.

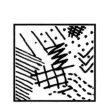
CONTRASTING AND VARIED SURFACE TEXTURES: PROJECTS EXCITED MOOD.

Responses to Lines

A zigzag line says something completely different than a spiral. These lines can be worked into any composition to lead the viewer's eye at the appropriate speed and with the appropriate energy. The lines actually create different physical responses in viewers.

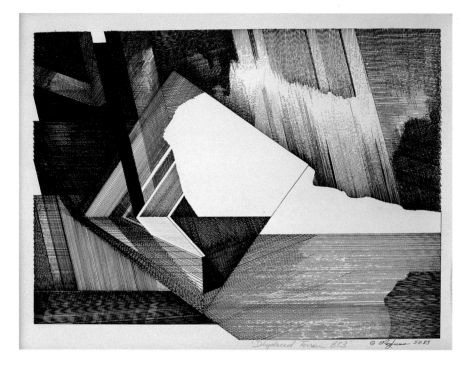

Precise Lines

Line can have many appearances. In this work by Rodums, a very controlled and orderly approach projects a statement of precision. Using a lining pen and ruler, Rodums achieves the clean look of a mechanical rendering combined with the visible passion of self-expression.

Displaced Terrain, Oliver Rodums
Pen and ink, 11" × 14"

Bold Lines

In a striking image designed to stop the viewer cold, just as a locked door would, Killeen makes use of motionless and bold gesture that sits powerfully within his picture plane.

Fulcrum, Earl Grenville Killeen, Watercolor, 9¾" × 13¼"

Dancing Lines

The encompassing line Rosenberger used to portray Ray looks toward the spontaneous for its speed and flow. Yet it carefully describes the edges and forms in a deceptively controlled manner as it swirls and dances to the very edges of the paper.

Ray, Priscilla Taylor Rosenberger, Conté, 24" × 18¾"

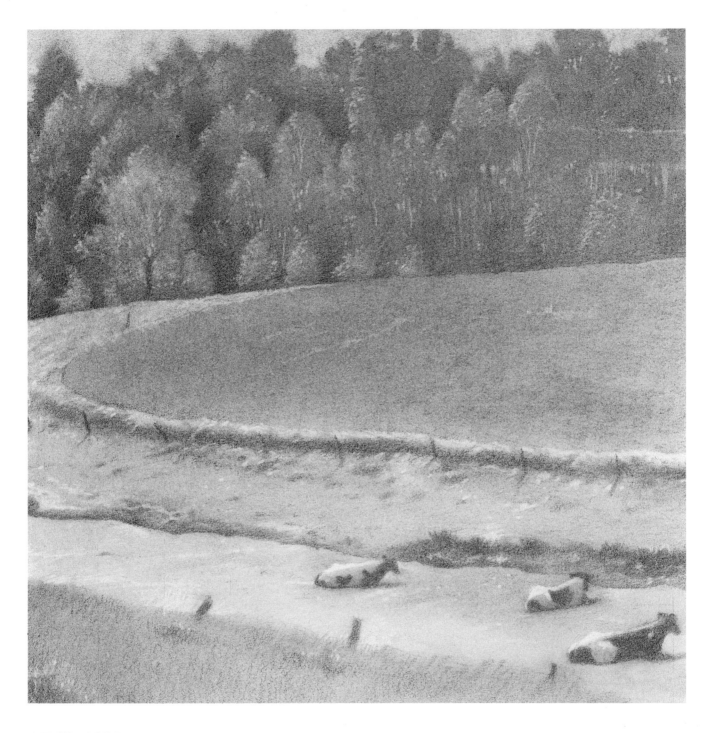

THE INSTRUMENTS OF APPLICATION

The nature of the line you make depends not only on its shape and direction but also on the tool used to produce it and the surface on which it is drawn. The rigid, precise stroke of a pencil will produce an entirely different line than will the soft crumble of pastel. Some mediums and their instruments of application let you adjust the pressure as you go and so change the value and thickness. Any application with a brush, for example, would provide this flexibility. On the other hand, ink in a ruling pen must by its nature remain constant. Experimentation with different mediums will help you explore the possibilities.

Soft Lines

Most lines fall somewhere between the highly controlled and the highly spontaneous. Reinbold's markings exhibit a conscious concern for every stroke. Nothing is unintentional in this work, but his medium and application soften the look from mastery to aesthetic refinement.

Resting Under Trees, David Reinbold, Conté pencil, 10½" × 10⅜", Private Collection

THE FUNCTION OF LINE

Line divides and defines. It tells us what we are looking at and where it is in relation to the space surrounding it. A simple horizontal slash can divide sky from ground. Two converging lines establish a sense of depth. By comparing and contrasting one line with another, we can measure and define size, location and depth. All of this information helps us to reach some conclusions about a drawn object's nature.

Contour

As a simple line becomes more complex and encloses itself or joins with other lines, it becomes the basis of shape, which further defines what we are perceiving. The most basic of shapes is the contour. A standard contour drawing is a line of relatively consistent width that closes into a particular configuration, establishing the outside edge of an object seen against a background. The first shoe drawing illustrates the basic contour drawing.

Contours are the simplest possible description of form. We may trace around an object quickly or with studied detail, but the value gradations of the interior of the shape remain a mystery.

Weighted Contour

From the simple contour drawing, everything you add increases detail and definition. If you change the contour line from thick to thin throughout its length, you establish a delineating edge adding variety and providing additional information on an object's mass. In the second shoe drawing, the widening of the line defines the compression of the leather or illustrates the depth and volume of the sole and space beneath it. The line thins in other places to show that the toe box pushes out under stress. Describing

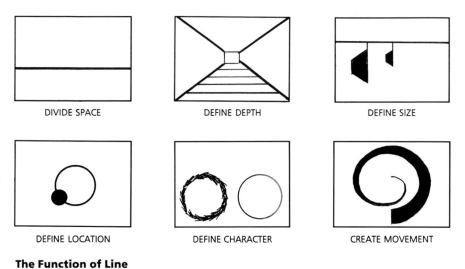

DIVIDE SPACE DEFINE DEPTH DEFINE SIZE

DEFINE LOCATION DEFINE CHARACTER CREATE MOVEMENT

The Function of Line
The functions of line are many. Lines define size, space, distance, location and an object's character.

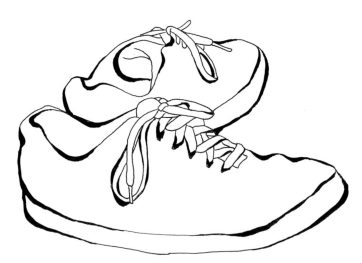

Contour Drawing
The most basic defining line is the contour. As its name indicates, it does little more than define the outside edge of a shape. No attempt is made to indicate a more complex linear illustration of volume.

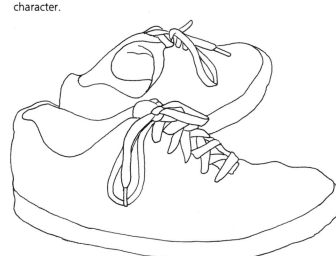

Weighted Contour Lines
The weighted line goes a step beyond the simple contour. Here, variations in the thick/thin relationship of the line begin to provide an idea of mass and depth. As we look at this drawing, a widening or increased weight along the line will tell us where the leather of this shoe bunches up into a thicker mass. A widening line on the lower perimeter also suggests a shadow beneath the shoe's sole, which would indicate depth.

recesses, bulges and areas that advance and recede helps the viewer establish a light source and, therefore, a value rendering.

The Next Step

As you move into the realm of value rendering, you move toward establishing a naturalistic or realistic image that line drawing is not. Line drawing is symbolic artistic expression—an interpretation of objects that do not exist, as actual objects exhibit mass and weight. As you define interior space, you move from two-dimensional representation toward a three-dimensional illusion of complex definition.

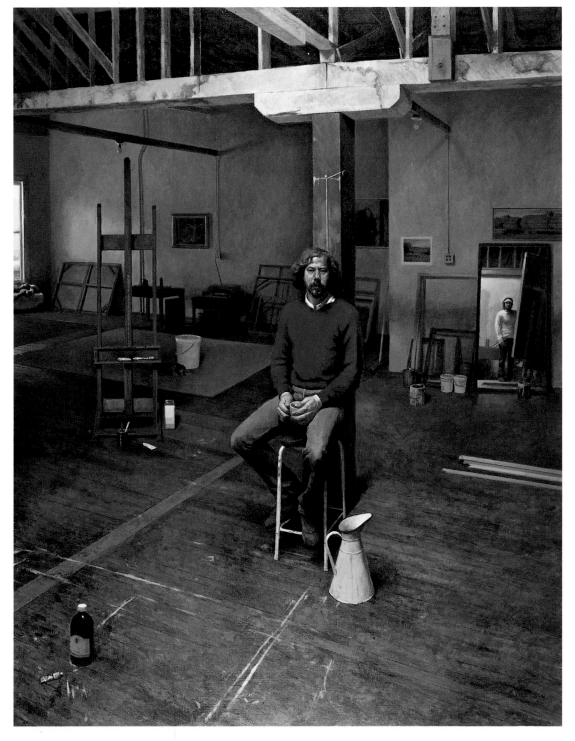

Lines at Work
All of the functions of line are evident in this painting. The lines pull us right to the composition's focal point, Doug Ferrin.

The Artist's Studio, Doug Ferrin
Jim McVicker
Oil, 78" × 54"
Collection of Mr. and Mrs. Daniel Jacobs

TWO MORE TYPES OF LINE

Before moving on to the construction of form, I want to mention two more types of line. One is visible and one is imagined. Both come into play when discussing the effectiveness of our art.

Rythmic

When I spoke of simple line, I mentioned movement as a characteristic. When a viewer looks at a work as a whole, the coalescence of multiple directional lines establishes a movement to the painting that may be different from movement within individual parts. This union of individual directions gives a work its rhythm and its flow. In *Vermont* by Richard Hamwi, there is not only a strong collection of horizontals that establish a horizon and indicate depth, but also a wonderful sense of rhythm. While these lines actually move from left to right, their form and motion move us up and down as well as from side to side throughout the piece.

The Eye Path

The other line to consider is provided by the viewer, mediated by the artist's help and direction. It is the invisible line established by the

A Sense of Rhythm

This painting's series of successive horizontal lines gives the imaginary landscape not only its horizon, but also establishes a sense of distance as their ascension toward the top of the picture plane creates the illusion of receding space.

Vermont, Richard Hamwi, watercolor and ink collage, 16" × 12"

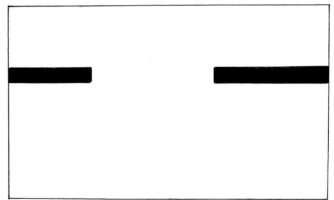

Implied Closure

A line that remains incomplete in its rendering by the artist will be fully constructed by the viewer's eye.

eye's movement as it sweeps across the painting. This eye movement will draw in and fill in areas that were left out for the sake of good design. The viewer's mind will fill in these lines and complete shapes because of implied direction and closure. The line that the eye follows pulls viewers into a work where they must participate with their own emotion and imagination.

THE BEAUTY OF LINE

Line is much more than description and utilitarian function; it is feeling. As it moves across our paintings, it takes us with it. It swirls, it flies, it rests, it has the ability to activate perception. It encompasses us with the simplest minimalist marks. Far beyond its figurative purpose, it can be appreciated by all for its inherent beauty.

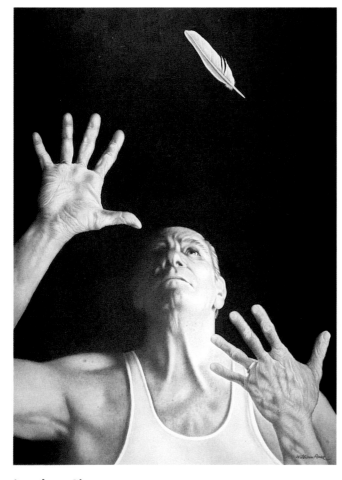

Imaginary Line
The line that Persa establishes between the subject's eye and the descending feather is drawn in by the viewer's imagination. This invisible connecting link is the most powerful line in the piece.

Fly Away, William Persa, Watercolor, 30" × 20"

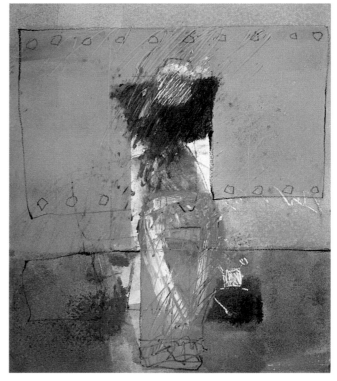

A Combination of Expressive Marks
All of the best qualities of line come together in this print by Liu: the expressive energy, the contrast of delicate against bold, the somewhat softened lines of the monotype process defining the object from the ground, and, of course, the feeling that is communicated from one person to another through this combination of simple marks.

Wall Marks #42, Katherine Chang Liu, Monotype, 14" × 12"

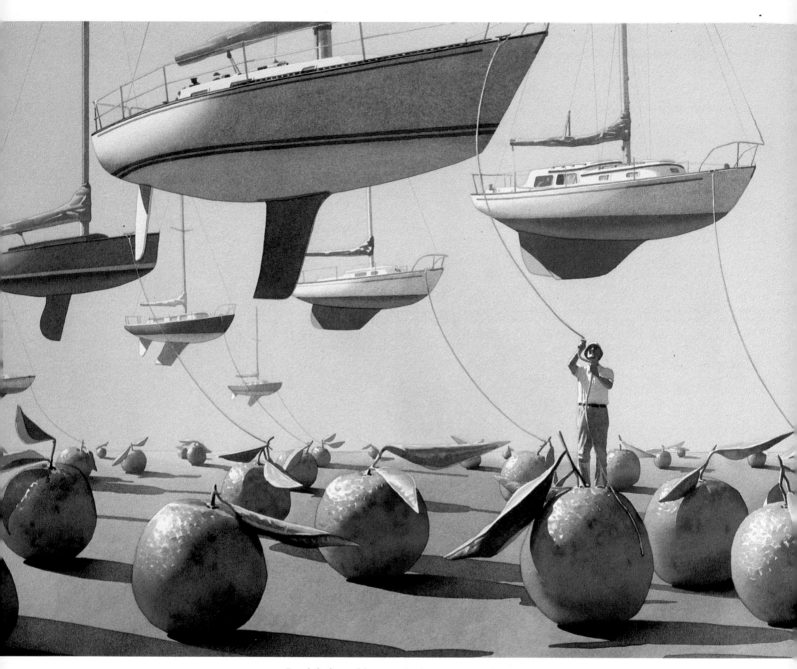

Good design with great shadow patterns will only work if the dark and light value relationships are there. Moore handles this task masterfully to make his objects believable. In this watercolor, he concentrates on value placement and builds up watercolor washes until the desired colors and contrasts are reached. Through this process he creates a motionless image that moves the mind.

The Orange County Anchor Man, Scott Moore, Watercolor, 32" × 42", Private Collection

A Quick Guide to the Vocabulary of Value

I n considering what makes his paintings successful, Scott Moore places the tool of value in the number one position. "I want viewers to believe what they're looking at. I try to do that with a convincing light source, and the only way to make the lighting real is to make sure the value is correct."

This is a particularly thoughtful way of expressing the importance of value, because it's not the light source alone or the value rendering alone that creates a believable image; it is how these two aspects are fused together that creates convincing art. The effect of a strong dominant light source on value gradation, form definition and cast shadow will unify a painting, creating a feeling of wholeness.

Without light, of course, there would be no value. When light strikes the simple contour shapes that were discussed in chapter three, it fills their interiors with volume and helps define them as objects. It does this by sweeping across the topography of the subject, shifting as it goes from light through dark. We call these shifts value — a very important aspect of art, especially for artists working with realism.

VALUE FOLLOWS FORM

When we view an individual or specific object, we receive an enormous amount of visual information from observing the light as it falls onto and is reflected off the object's surface. Light moves across a form and establishes important contrasts. When drawing or painting, an artist's job is to observe and compare these contrasts and then reproduce them to create an illusion. Value rendering allows you to perform the trick of representing a three-dimensional object on a two-dimensional surface.

Building Blocks of Value

The very nature of your subject establishes the value pattern it projects. Light strikes different forms in different ways. Value can gently slide around graceful curves or abruptly start and stop to define flat surfaces of uniform tone. A flat-sided geometric form such as a cube or pyramid will have large, solid areas of shade with the light

or the dark appearing to be equally dispersed across each flat side.

A rounded softer form—a sphere or cylinder—has shade that gradually moves from light to dark, creating the impression of curving. Look again at Scott Moore's painting (on page 34) and how he defines the oranges' roundness.

Looking at the simple value models, you can imagine how they serve as the building blocks for rendering almost any object in nature. A sphere becomes Moore's oranges or the beginnings of a face, a cylin-

der becomes an arm or the branch of a tree, and a cube becomes an architectural structure or a table, as in the drawing *Baltimore Light* by Scott Field (pictured on the opposite page). Field bases his compositional form on these classic building blocks.

When you begin a painting, examine how your subject breaks up into these basic forms and apply the appropriate value contrasts. Observation and practice are the keys to success.

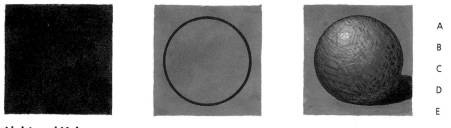

A
B
C
D
E

Light and Value

Without light there would be no visual world. Without light there would also be no values. When light strikes an object, it gives that object form and definition. The components of this definition—(a) highlight, (b) light, (c) shade, (d) reflected light and (e) cast shadow—are the heart of the vocabulary of value.

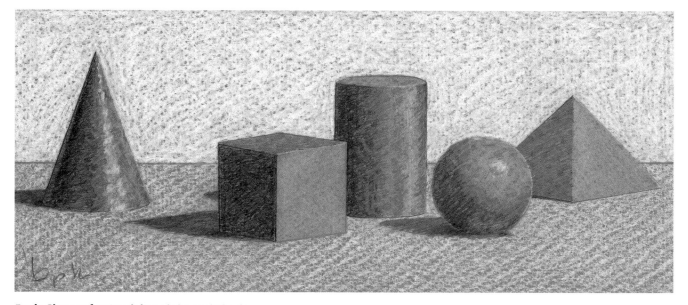

Basic Shapes for Studying Light and Shade

When you draw or paint forms in nature, you are simply reproducing the light and shade patterns that you see falling on their surfaces. A simple model such as a sphere, cylinder, cube, pyramid or cone can act as a tool to help you understand how the values fall on these varied surfaces. Examine your subject, then break it up into some combination of these model forms for a quick perspective on your subject's value properties. In these quick drawings, I worked on a midrange tone paper that allowed me to build in both directions, toward strong white and dark shade, for greater contrast.

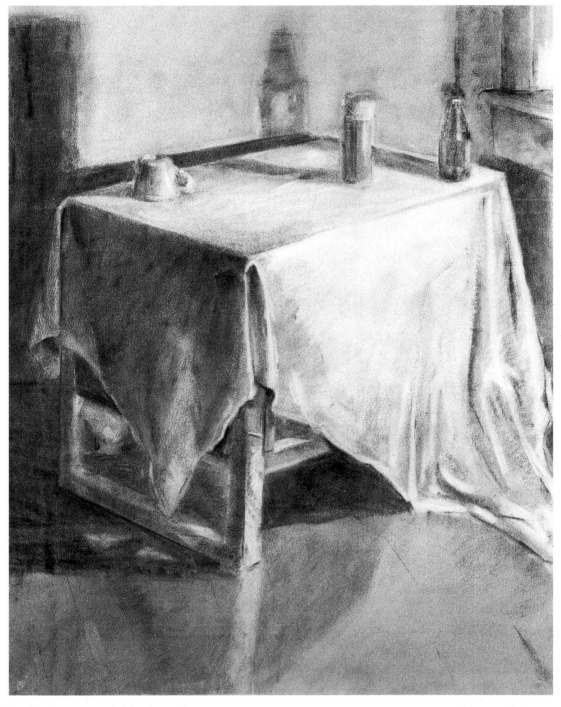

Basic Shapes in a Finished Drawing

Field's charcoal drawing illustrates how value contrasts change across various shapes. Here, the main focus of the table has the typical characteristics of a rendered cube. However, the stark flat areas are broken up and softened by the slight gradations of the cylindrical folds in the tablecloth. The cup and glassware show the highlight and shade patterns of the cylinder and cone, respectively.

Baltimore Light
Scott Field
Charcoal on paper
26" × 21"

Highlight and Shade

The highlight is the area of an object that receives the greatest amount of light, or the "direct hit." Highlights are very important in helping the viewer establish the direction of the light source. Shade, by contrast, occurs in any area turning away from the light source. Recesses hidden from the light take on varying degrees of shade. From human skin to a silver bowl, all objects exposed to direct light will have this highlighted and shaded appearance. The reflective quality and surface texture of the subject determine the degree of contrast.

THE ROLES OF THE CAST SHADOW

Also important to an object's artistic depiction are cast shadows. These dark projections develop opposite the light source wherever the light rays cannot penetrate the object's mass and help define visual form.

Because they are so important to establishing both depth and detail, cast shadows should not be underrated or casually applied. Not only do they help define the direction of the light source, but they can also suggest to the viewer how far away that source is from a subject. As a child, I remember watching shadows lengthen as the day progressed. The same phenomenon can be expressed in your art. The greater the distance or the sharper the angle between the light and the object, the more drawn out the shadows will be. Also, as distance between the light source and the object increases, the shadows' edges will soften and the value intensity decrease.

Define Reality

Attention to details like this increases the believability of illusion.

The components of value to-

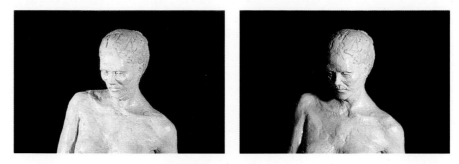

Placement of the Light Source

Any adjustment of the light source shining on an object can make a very dramatic difference in the placement and intensity of its delineations. It can also change the expressive content. As you can see in this example, when the light is dispersed evenly over the subject (above left), the subject looks flat; details are bleached out. The high contrast of the side illumination (above right), on the other hand, provides a great deal of interest through the contrast of values from highlight through deep shadow.

Female Figure, Scott Field, Plaster, 4' × 13" × 8", Collection of Stefanie Field

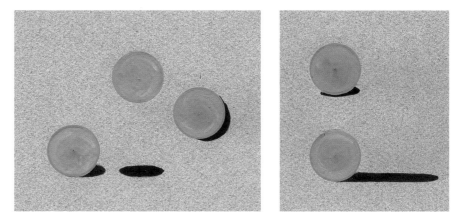

Cast Shadows

Cast shadows help the viewer to define the illusionary space. Is the subject sitting on, floating above or attached to a surface? These shadows help us fix the subject's location and therefore give a sense of understanding and order. They will also define the direction of the light source and its distance from the rendered subject.

gether work toward producing an image that subconsciously says, "Yes, that's right." Regardless of the subject, when depicting realistic objects that you want your audience to recognize, you need to define your illusionary reality correctly. When your subject moves into the realm of fantasy, as in Scott Moore's *The Orange County Anchor Man* (page 34), this becomes even more important since you're asking viewers to suspend disbelief, making the unreal believable. Moore's use of value and cast shadows does this well.

Position Objects in Space

Cast shadows place an object in space relative to other elements in the picture plane. Is it sitting on, resting in front of, or floating above a stable ground? What do Scott Moore's shadows tell us about the placement of the oranges and the boats? This floating impression is achieved through simple cast shadows. Simple, yet critical.

Provide Creative Interest

From a tone and intensity perspective, cast shadows can enliven your art with a character all their

Adding Interest With Shadows

As with so many secondary aspects of painting, attention to details such as interesting shadows can make a world of difference to a finished work. Rosenberger's watercolor is a marvelous example of how simple cast shadows enliven a work. Multiple edges, adjustments in depth of tone, and the subtle muted colors add greatly to this composition's interest.

Contemplating Edibles, Priscilla Taylor Rosenberger, Watercolor, 7½" × 14½"

own. They are not just flat, black shapes that mirror their parent, but a combination of varying degrees of darkness and different edges that provide creative interest. Is there more than one light source? Is that source close or far? If we are outside, how does the weather affect our shadows? Is the sunlight harsh and direct, or is it diffused by a lingering haze? Priscilla Taylor Rosenberger's watercolor *Contemplating Edibles* is a fine example of how this attention to detail makes a world of difference to the finished painting.

REFLECTIONS ON REFLECTIONS

One final characteristic of an object's value is reflected light—the brightness and color shifts caused by the light that "bounces off" neighboring objects. Generally, reflected light affects a subject by causing areas of higher value or lightness in an otherwise dark shaded zone. Looking at Scott Moore's *The Orange County Anchor Man* (page 34), the lively value and color interaction on the boat hulls results from light being absorbed from surrounding lit surfaces.

Here again, the key to getting it right is careful observation and artistic reproduction. Also, it is important to know where to look and what you can expect to see when you look. This is particularly true of the often complex effects of re-

flected light. Look around you. Spend some time studying the essential changes this small element has on the whole.

FUNCTIONAL VALUE

The blending of light to dark values to define an illusory form is called *chiaroscuro*. The word is derived from the Italian words *chiaro*, which means light or clear, and *oscuro*, which means dark or obscure. This technique was first practiced during the Renaissance, as artists moved away from decorative, two-dimensional line drawing to capture an increased sense of space, reality and true form in their work. Chiaroscuro allows the subject to advance out of its surrounding space. Barbara Kacicek's charcoal and graphite drawing *Venus Natu-ralis #1* (below) illustrates this well, as the figure curves in and out and back and forth with a highly realistic sense of modeling.

Contrast of Light and Dark

Increasing the contrast between light and dark will increase the drama and mystery of the paintings you produce. In Douglas Wiltraut's painting *Swept Away* (right), the intensely dark shadow at the bottom of the composition uses value so powerfully that it actually becomes part of the subject. In these dark recesses where form is lost or obscured, our imagination must supply the missing detail. As a compositional technique, this approach also focuses the viewer's attention on particular areas.

Perceived Value

Value relationships are perceived as they relate to surrounding areas, not as isolated elements. If you want something to stand out, increase the contrast of neighboring values. The same gray tone will appear darker or lighter depending upon the value behind or beside it, as seen in the illustration (below right).

Creating Roundness and Depth With Chiaroscuro

Defining form with value gradations rather than with outlines or gesture is known as *chiaroscuro*, a technique that allows us to create complex illusions of roundness and depth. This work is a stunning example of how chiaroscuro can pull realistic form out of a flat surface. Through careful observation and meticulous rendering of the light and shade interaction, Kacicek has crafted a beautifully unified image as value sweeps across the figure from implied form in darkness at the right to fully illuminated detail on the left.

Venus Naturalis #1, Barbara Kacicek
Charcoal and graphite on paper, 12" × 17"
Collection of Mr. and Mrs. Harvey Cooper

A Dramatic Use of Light and Dark

Wiltraut's dramatic use of value presents contrasts so intense that form within the dark areas is all but obscured. This dynamic, moody approach establishes a focus of mystery and the unknown in this undefined dark region, allowing the viewer's mind's eye to fill in the information. The exaggerated counterpoint also heightens the clarity and warmth that the light offers to the other areas of the painting.

Swept Away, Douglas Wiltraut
Egg tempera, 19″ × 27″
Collection of Dr. and Mrs. Bruce Viechnicki

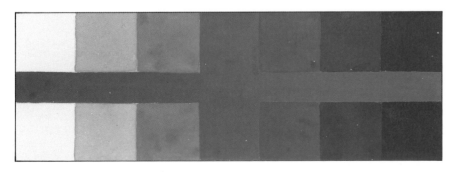

The Effects of Neighboring Values

The value of an object is not only determined by its own intensity, but also by the relative relationship to its neighboring areas. As the gray stripe moves across this illustration, its appearance seems to change depending upon the value intensity of the background, although its actual value remains constant.

41

ADVANCING AND RECEDING SPACE

In the natural world, sharp hard edges, like stark value relationships, are not common. But, for design-oriented art, these characteristics can be very effective. In his silkscreen *Arrangement in Black and White: The Meal* (right), James DePietro eliminates intermediate gray tones to flatten his form. Then he applies sharp lines to create a decorative, design-oriented representation. These sharp edges and strong contrasts present us with lucid, crystal-clear images that stand out from the surrounding background in an unrealistic way.

Designing With Hard Edges
Eliminating the midrange gray values for a sharply contrasting black-and-white palette produces a flat, design-oriented image. The hard edges increase this "design" feel.

Arrangement in Black and White: The Meal
James DePietro, Silkscreen on paper
11" × 16"

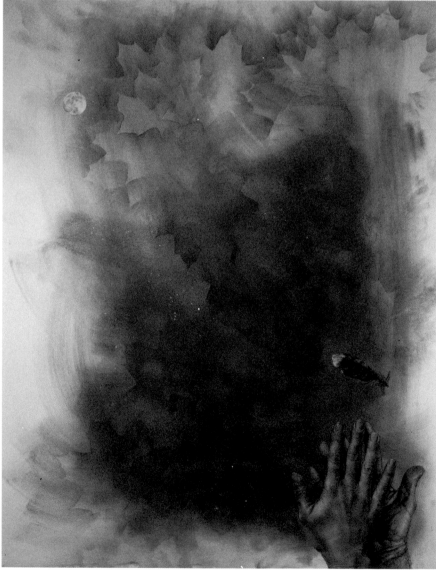

The Impression of Advancing and Receding Space
Great clarity, detail and value contrast will define a rendered object as closer in our field of vision than those objects drawn with less-detailed features. For this reason, the hands and feather in Kacicek's drawing appear to be in front of the leaves and moon.

Following My Hand, Barbara Kacicek
Charcoal, 18" × 24"
Collection of Ute Arnold

Softening Edges

If you chose to paint a realistic image of zebras and pandas in their natural environments, you would need to soften the edges of the figures so that they would not only blend into the background more honestly, but also take on a roundness that would give them a depth that moves them forward in visual space. The soft edge approach provides atmosphere and space around a subject.

Defining Space with Degrees of Clarity

The impression of advancing and receding space can also be handled with value complexity and detail. Objects closer to the viewer show greater contrast than those at a distance, which are less contrasting and less defined. Your highlights—white tones and light areas—move toward the viewer; dark, blackened areas recede.

These approaches to establishing depth, focus, visual interest and detail bring mood and purpose into a work.

Defining Depth With Value Contrasts

The dark void in the lower center portion of Mitchell's watercolor defines the depth of the theater entrance. Deep values like these will appear to recede and light tones appear to move toward the viewer.

Living for the Weekend
Dean Mitchell
Watercolor, 18" × 24"

ANOTHER VALUE OF VALUE

Beyond defining form and lending a sense of reality, the value contrast you employ in your art will project a particular mood. Using certain value relationships, you can pass on a particular feeling that enhances your point of view. We all know how bright days of sunshine or overcast skies can affect a person's outlook. The same principle is true in painting, and value is the vehicle.

In David Reinbold's drawing, *Angel Feet* (below right), he employs relationships of soft, subtle tones to communicate a sense of calm and tenderness. The passive, restful image of intimacy relies on the closely related values of these warm sepia tones to share his feelings of gentle love.

Barbara Kacicek, on the other hand, uses strong and striking con-trast, from intense black through white, in her drawing *The Escape From Obsessive Dreaming* (below left) to create an atmosphere of mystery and drama. Here she uses value's descriptive qualities to express the psychological and emotional energy we often encounter in our dreams.

To some degree, value is a more important tool in black-and-white and neutral tone expression, as seen in these two works. Color provides its own kind of delineation, but the importance of value in color work should not be underestimated. Mood interplay based on value intensity is always at work. The forceful appearance of Douglas Wiltraut's *Swept Away* (page 41) relies on this juxtaposed value contrast to communicate its powerful mood, just as Priscilla Taylor Rosenberger's close value relations in *Contemplating Edibles* (page 39) project calm beauty.

VALUE AS PATTERN

Most of this chapter has focused on the importance of value in expressing reality and its forms. Value is also an important component to be considered in design and in abstract, and non-objective work. Contrast increases interest, energy and excitement. When we replace form with pattern that moves across the picture plane, the interaction of light and dark remains. While representing volume may not be as important, we are still working with depth and relationships, as one area relates to another and to the whole. Value is a very important tool in this regard.

I am including (top right) a

Subtle Variations in Value

Reinbold emphasizes the aspects of serenity and tenderness in his drawing by using soft sepia tones of closely related value. This passive, restful image relies on these subtle variations to project the artist's feelings of gentle love.

Angel Feet
David Reinbold
Conté, 27" × 18"
Courtesy of Capricorn Galleries

Sharp Contrasts in Value

The sharp contrasts and intense deep tones provide a compelling atmosphere of mystery and drama. Kacicek uses the tool of value to communicate the emotionally charged essence of a dream.

The Escape From Obsessive Dreaming
Barbara Kacicek, Charcoal, 36" × 29"
Courtesy of Capricorn Galleries

black-and-white reproduction along with the original color reproduction of Richard Hamwi's cut-paper collage *Valley* to illustrate how effective his use of value interaction is in terms of shape definition and also as a catalyst for the overall energy and movement within the work. In this type of art, projected mood as well as the design elements of contrast, interactive movement and edges relies on value.

Not only do all colors carry specific tone and value levels (as we see in Richard Hamwi's work), but the addition of the value scale, from white through black, to any single color provides a full range of contrast within that color.

The Color-Value Relationship

Whether an artist portrays deep space with its highly rendered form or shallow space with a focus on design and pattern, value contrast is an important factor. This tonal relationship must also be considered when working in pure color as every hue has inherent value. Hamwi's *Valley* shown with its black-and-white counterpart forcefully illustrates the sometimes surprising values color carries. His experience and knowledge of this color-value relationship synthesize to make these intricate paper weavings sing.

Valley
Richard Hamwi
Watercolor and ink
collage, 12" × 16"

An absolute sense of sensation reaches out and stops us in the simple statement Killeen is making with this red door.

Torpor, Earl Grenville Killeen, Watercolor, 12½″ × 9″

A Quick Guide to the Vocabulary of Color

C olor is a powerful tool for an artist. It is vividly descriptive. It affects the emotions immediately and with great impact. Practitioners of art, science or psychology could make a lifelong study of color and the responses it evokes and still not understand all of its mysteries. For our purposes, this chapter will simply examine some of the basics of color harmony, color interaction, mood and personal palette. It will concentrate on how color can work for you to enhance your artistic voice.

THE COLOR WHEEL

Today's systems of color harmony are relatively new. In 1676, Sir Isaac Newton discovered that white light, when passed through a prism, separates into distinct colors that vibrate at different frequencies. The visual result is the rainbow spectrum. By bending this flow of color into a circle, Newton created the first color wheel—a basic tool for creating color harmony.

To understand color theory, look at a color wheel that's composed of twelve hues arranged in a circle in spectral order from red through violet (see below). Even in this simple circle, basic concepts are at work:

Primary Colors

First, there is the framework of the color wheel: red, yellow and blue. These are called primary colors because they cannot be mixed by adding other colors together.

These three primaries, when mixed in pairs, will theoretically produce all other hues within the wheel. If all three primaries are mixed, the result is a range of neutral colors from gray-black to gray-brown, depending on the percentage of each primary used.

Secondary Colors

Next, there are secondary colors, created by mixing any two of the primaries in approximately equal amounts. In these secondary mixes, red and yellow yield orange, yellow and blue yield green, and blue and red yield violet.

Tertiary Colors

Finally, there are the tertiary colors; they result from mixing one primary color with one secondary color to make hues such as red-orange, yellow-green, blue-green, blue-violet and red-violet. An endless variety of intermediate hues could be created and included in this wheel by mixing different primaries, secondaries and tertiaries in varying proportions and combinations.

With this color wheel you can investigate different types of color harmony, which are described on the following pages.

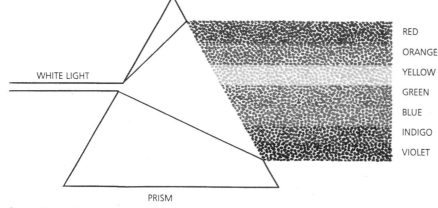

The Colors of the Spectrum
Color is everywhere, even in the makeup of the white light that surrounds us. When this white light passes through a prism, it reveals spectral color from red through violet.

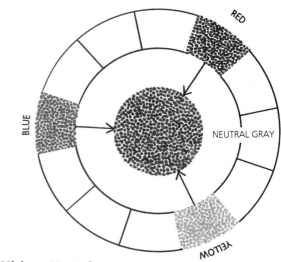

The Color Wheel
By bending the colors of the spectrum into a circle, we form the basic color wheel of twelve hues. I've designated the primaries with the number one, the secondaries with the number two, and the tertiaries with the number three. All of the ideas about color mixing in this chapter are based on this wheel.

Mixing a Neutral
In this illustration you can see that the three primary colors of red, yellow and blue yield a neutral gray when mixed together.

MONOCHROMATIC HARMONY

This is the most elementary color harmony. Here, you take a single hue from the color wheel and create a scale of different values by mixing it with varying amounts of neutral gray or pure white. The colors in this range all interact harmoniously, because they all have the same base hue. You can vary the look of this limited range by using strong contrasts in values, such as high-value lights and low-value shadows (see below), or by working with closely related values. You can use this value scale in any color harmony scheme.

ANALOGOUS HARMONY

Hues that are adjacent to each other on the color wheel create analogous harmonies. These hues are related since they flow from one into another. This close relationship creates a soothing, pleasant effect. When used in a painting, these schemes usually favor either the warm or cool side of the spectrum and elicit a corresponding emotional response.

In an analogous scheme, harmony is tightened if the colors are related in hue. For instance, Michael Kessler's combination of orange through red-orange will appear more cohesive than if he worked with violet and red and orange, as William Persa has (see page 50). Both approaches present a unified color range, but one is tighter than the other.

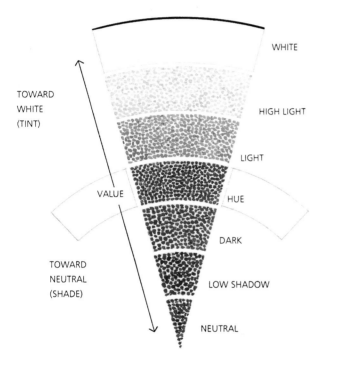

One-Color Scale of Values
By adding varying amounts of white or neutral gray you can create great variety within a color, as you can see in this illustration (left) in which I have expanded the red-violet hue.

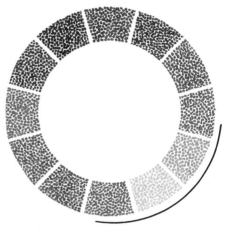

ORANGE, YELLOW-ORANGE, YELLOW, YELLOW-GREEN (IN THEIR NATURAL SEQUENCE)

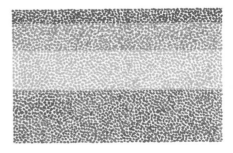

Analogous Harmony in Yellow-Orange
Combining neighboring colors on the color wheel results in a pleasing analogous harmony. The yellow-green, yellow and yellow-orange scheme is an example of this range.

Monochromatic Harmony in Green
In this monochromatic illustration, I built the entire image from a single base hue in the green range. I created variations by graying or whitening the color.

MONOCHROMATIC VALUE SCALE
(TOWARD NEUTRAL) (TOWARD WHITE)

Harmony in Red and Orange
In an analogous scheme where the colors employed are clearly related in hue, harmony is tight, as in Kessler's painting. Kessler works with combinations of orange through red-orange, building up a surface of one color on top of another that establishes a visual vibration for the viewer.

Untitled, Michael Kessler, Acrylic on paper 14" × 22"

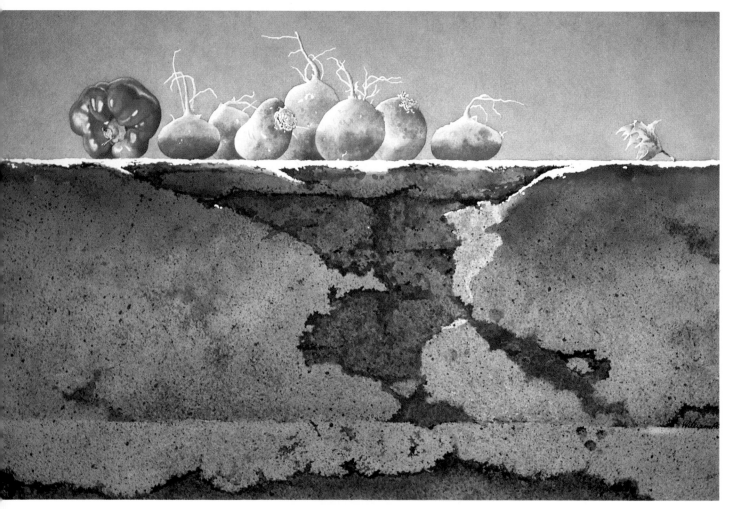

Harmony in Violet, Red and Orange
An expanded analogous harmony moves around the color wheel to include a larger range of neighboring colors. In this watercolor, Persa works with a violet-red-orange scheme.

Turnips and a Red Pepper, William Persa, Watercolor, 30" × 20"

COMPLEMENTARY HARMONY

Quite different from closely related analogous hues are complementary harmonies — harmonies between colors that strongly contrast to one another. This group is divided into three distinct harmonies of varying contrast: pure complementary harmony, split-complementary harmony and triadic harmony.

Pure Complementary Harmonies

Pure complementary harmonies combine hues that are directly opposite each other on the color wheel; these will have the greatest contrast, as is clear in the illustration (below right), in which yellow is the complement of violet or yellow-green is the complement of red-violet.

You can achieve two effects by combining pure complements. Placed side by side, they will brighten or intensify each other. When mixed together, however, or placed side by side in areas so small that the effect is one of blending, the result will be a neutral gray comparable to mixing the three primaries. The neutralizing property is a handy tool for dulling or softening a color that may appear too brilliant.

*Blue and Orange
Still Life*
Daniel E. Greene
Oil, 40″ × 40″
Le Franc Bourgeois
Museum, Le Mans,
France

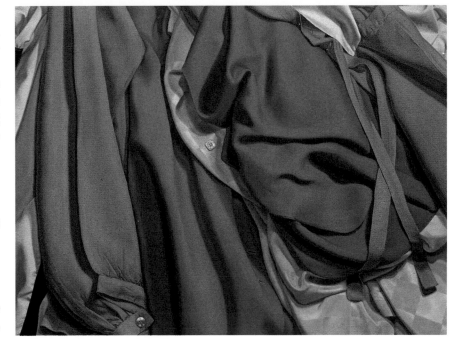

Complementary Harmony
In this exciting painting, Luhman works within the blue-orange complementary scheme. The blue variation functions with a change of intensity rather than a change of hue. The hot orange and cool blue complement each other beautifully.

Orange X
Denise Luhman
Acrylic and oil,
14″ × 18″

Complementary Color Schemes
A complementary color scheme can be made of any pair of opposites. A twelve-hue color wheel contains six pairs of complements. This illustration shows harmonies made of two complements. These will always be composed of one warm and one cool color. The blue-violet and yellow-orange pair illustrates the gray that results when complements are combined.

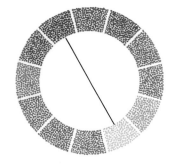

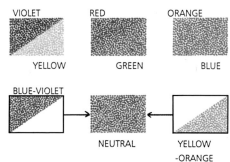

VIOLET — YELLOW
RED — GREEN
ORANGE — BLUE

BLUE-VIOLET → NEUTRAL ← YELLOW-ORANGE

Composing With Complements
Greene deliberately chooses the strikingly dissimilar blue and orange complements for his foreground and background. He further emphasizes the focus by repeating these colors in the objects portrayed.

Split-Complementary Harmony

The split-complementary harmony has slightly less contrast than the pure complementary harmony. In this scheme, you combine one hue with the two colors that fall on either side of its complement directly opposite on the color wheel (see illustration below). For instance, if blue is your chosen hue, go directly across the color wheel to orange. Then use the colors on both sides of orange—yellow-orange and red-orange—to build your harmony.

We can see this exciting combination in Daniel Greene's painting *Blue and Orange Still Life*. This approach offers you greater color variety than the pure complementary harmonies can.

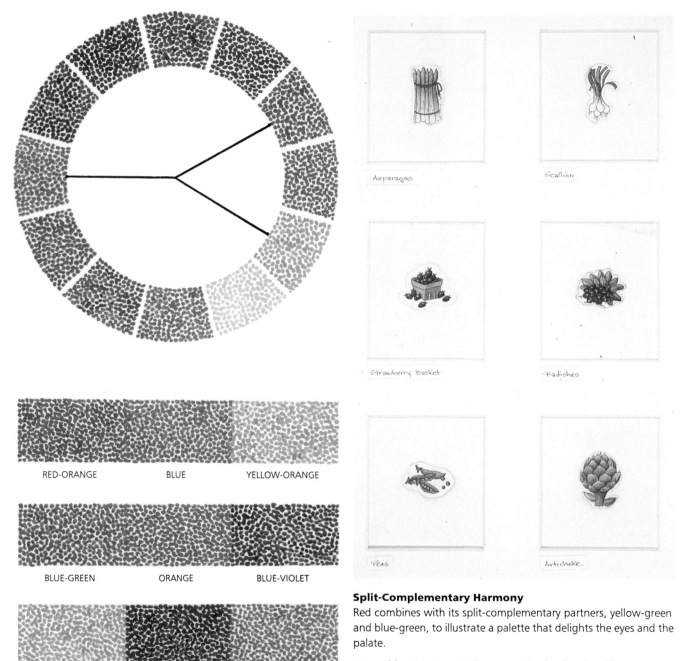

RED-ORANGE BLUE YELLOW-ORANGE

BLUE-GREEN ORANGE BLUE-VIOLET

YELLOW-ORANGE VIOLET YELLOW-GREEN

Split-Complementary Harmony

Red combines with its split-complementary partners, yellow-green and blue-green, to illustrate a palette that delights the eyes and the palate.

Vegetables #1, Jane W. Conneen, Hand-colored etching, 2¾" × 1¾"

Split-Complementary Schemes

Instead of using the direct complement of a color, the split complementary scheme uses the colors on either side of the direct complement as illustrated here, where blue would be connected with red-orange and yellow-orange.

Triadic Harmony

The third and final complementary scheme is a triad, or three hues spaced equidistantly on the color wheel. On the twelve-hue wheel, there are four possible triads: the primaries; the secondaries; the intermediate hues of red-violet, blue-green and yellow-orange; and the intermediate combinations of red-orange, yellow-green and blue violet. Each of these combinations creates a very different effect, as you can see in the illustration (right).

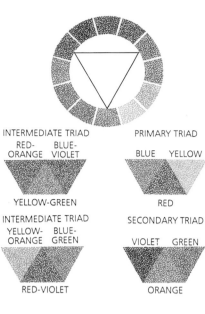

INTERMEDIATE TRIAD
RED- BLUE-
ORANGE VIOLET

YELLOW-GREEN

INTERMEDIATE TRIAD
YELLOW- BLUE-
ORANGE GREEN

RED-VIOLET

PRIMARY TRIAD
BLUE YELLOW

RED

SECONDARY TRIAD
VIOLET GREEN

ORANGE

Triadic Color Schemes

Triadic harmonies are combinations of three colors at equal distances from each other on the color wheel. The primary colors, red, blue and yellow, form one triadic possibility, the secondaries another; two intermediate triads also exist in our twelve-hue wheel.

Triadic Harmony's Unifying Effect

The unifying effect of triadic harmony used by Earl Grenville Killeen in his *Pipe Dream* is very appealing.

Pipe Dream, Earl Grenville Killeen, Watercolor, 10" × 10"

DOMINANT TINT HARMONY

To create a dominant tint harmony, you can use a variety of hues that will be unified by one overpowering hue. This harmony can be accomplished in two ways: The dominant hue can pervade all others in the work, as in *Sapphire* (below), in which the blue was either added to or airbrushed over all of the other colors; or large areas of the unifying color can take up the majority of the canvas space.

COLOR DISHARMONY

I'm not saying that you always should stay within the confines of these principles. While the overall impression should fall within the domain of one desired color harmony, rules should not prevent you from experimenting.

As you explore, remember that as red has its opposite in green, harmony has its opposite in dissonance, which has its place and uses. It can be exhilarating and insightful, leading you in new directions.

COLOR INTERACTION

Colors do not exist separately in a kind of visual vacuum. On the contrary, colors placed side by side will intermingle and affect each other. Knowing how colors interact is an important part of composition. Experience in color mixing and the study of color contrast will lead to an understanding that will serve you well.

I think of color interaction in two distinct and different ways. The first is optical mixing where colors intertwine, overlap and visu-

ally fuse to achieve a particular hue that is different from its separate colors. This approach is like palette mixing, as you will soon see. The second type of interaction is simultaneous contrast. This is a slightly more scientific approach in which you use neighboring hues to enhance the effect of your color rather than create a new one.

OPTICAL MIXING

Working with the pointillistic technique, I learned very early the importance of optical mixing. My personal goal was to share an image; I wasn't initially concerned with the scientific approach to color championed by the nineteenth-century pointillist Georges Seurat. However, knowing how adjacent colors mixed proved to be

Creating a Dominant Tint Harmony
To create the dominant tint harmony in *Sapphire*, I airbrushed a transparent blue over the majority of the painting. While spraying, I blocked the lighter areas with frisket. Then I finished by adding the dots individually with a pointillistic technique.

Sapphire, David P. Richards
Watercolor, 14″ × 33″

of the utmost importance. To avoid the monotonous look caused by filling any given area with a single color, I combined thousands of dots of multiple hues to achieve visual interest. What occurs when I do this is a mixing effect in which a blue dot and a yellow dot visually fuse to create the impression of green. A collection of red and yellow points will yield an orange sensation. Purple and yellow will move together to produce a neutral gray tone and so on.

Optical mixing simply requires an understanding of color mixing. Just as we would mix blue paint with yellow paint on our palette to achieve a green pigment, so we rely on visual perception to mix the colors in the viewer's mind's eye.

Pointillism

My pointillistic work is a good example of this principle. The colors I use are many and the dots are small, 1/32 inch or smaller. The larger the dot, or fragment of color, the farther we must back away from the painting to achieve the desired optical mixing effect. But pointillism is not an exceptional case. This principle of optical blending comes into play in varying degrees regardless of application.

Scumbling

Scumbling one color on top of another, for example, will achieve this blending effect. Scumbling is applying a dry brush layer of color over a previously applied layer. This effect can be seen in Michael Kessler's untitled acrylic painting (shown previously on page 50) in which his colors mix optically to create a visual massage for the viewer. Even a straightforward, traditional approach to color application will illustrate the visual mixing principle to some degree in the finished work.

Optical Mixing
The color interactions that occur in this painting result from optical mixing. In this effect, two dots of differing color visually fuse to produce an impression of a singular hue that is different from its components.

The Secret Garden, David P. Richards, Watercolor, 27" × 40"

A Pointillistic Approach
In this detail, we can see how variations of yellow-green, green, blue-green, violet and orange dots sit side by side, allowing the eye to blend them as we move away from the work. By placing the dots next to each other, rather than overlapping, and close enough so that additional marks won't fit in the interstices, I created an ethereal, orderly feeling.

Detail

Complementary Colors Project the Greatest Degree of Contrast
Simultaneous contrast will dictate that a red circle on a field of green will appear brighter than the same red circle on a neutral gray background.

Apparent Shifts in Analogous Hues
Simultaneous contrast is most obvious with direct opposites. But in this illustration of analogous hues we see a reaction also. Here a blue-violet figure moves closer to violet on a pure blue base, and the same blue-violet shifts closer to the blue element when the background is pure violet.

Varying Brightness
A hue neutralized by adding gray will appear brighter on a gray field and grayer on a field of the hue's original brightness.

SIMULTANEOUS CONTRAST

Simultaneous contrast is different. It rules how one color affects the hue, temperature, value and intensity of a neighbor. First theorized by Michel Eugène Chevreul of the Gobelin Tapestry factory in nineteenth-century Paris, it is one theme of his treatise *The Principles of Harmony and Contrast of Colors*. This book, which is still available, is the starting point of modern color theory. By applying this theory to your own work, you can increase the richness of color as well as improve the overall unity of your paintings.

Chevreul theorized that the direct contact of neighboring colors intensifies the difference—the contrast—between them. As we saw in the color wheel, complementary colors project the greatest degree of contrast. So, if we use red and green as an example, the rule of simultaneous contrast tells us that a red circle on a green field will appear brighter than the same red circle on a gray field. The red circles will appear to be different hues, but they are not. The difference is simply an illusion based on the effect of the field.

For contrasts of less intensity, we will still see results as long as there is a color relationship at play. In an analogous range, for example, a blue-violet figure will appear blue on a purely violet ground, but if the ground is shifted to pure blue, the blue-violet figure will appear to be violet.

Value and Temperature

In terms of value and temperature, we can also look to simultaneous contrast to understand the resulting effects. Any hue neutralized toward gray will appear brighter on a gray field and grayer

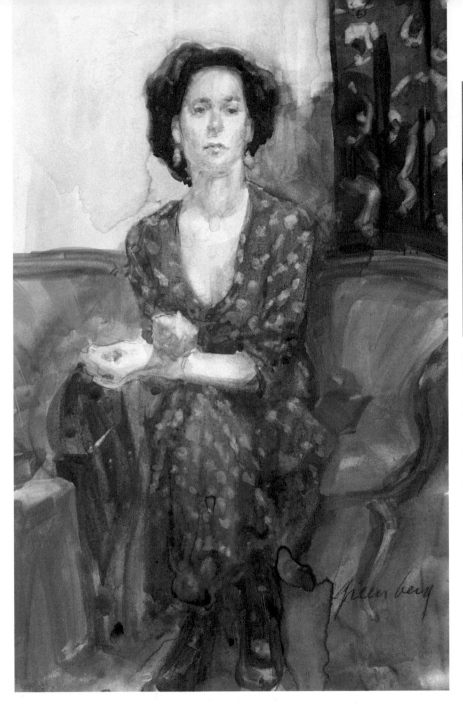

A Brighter Blue Due to the Halo Effect
Under the rules of simultaneous contrast, the neutralizing gray of the overshirt in Luhman's painting will heighten the impact of the luminous blue silk. Additionally, blue's complement—orange—will be picked up optically as a cast upon neighboring gray.

Black and Blue, Denise Luhman, Acrylic and oil, 14″ × 11″ (above)

Brighten Fleshtones With Neighboring Complements
An understanding of the effects of neighboring colors can be applied to heighten a painting's effectiveness. In Greenberg's watercolor, the complementary blue-green background and outfit make this model's peachy fleshtones appear bright, clear and healthy.

Lisa, Irwin Greenberg, Watercolor, 11″ × 17″ (left)

on a field of the hue's original brightness, as you can see in the illustration (left). In terms of temperature, a warm tone will appear warmer when surrounded by a cool tone, and a cool tone will appear cooler when surrounded by a warm tone.

The Halo Effect

Another aspect of simultaneous contrasting color is the halo effect, which happens when a color brings out its complement in a neighboring hue. For example, in Denise Luhman's oil painting *Black and Blue*, not only does the blue appear brighter because of its neighboring gray, but an orange halo, the complement of blue, can be perceived in the gray. This effect is most obvious when the neighboring color is a neutral, gray, black or white, but ultimately any color will be affected in this way. When planning your paintings, you must analyze your point of view and determine what will work best for each work. In Irwin Greenberg's portrait *Lisa*, the dark blue-green dress and curtain work perfectly with the peach-colored complementary fleshtones. The simultaneous contrast helps the artist to produce an image of vibrant life.

A FULL SPECTRUM OF EMOTION

Color affects us consciously and subconsciously, emotionally and physically. Nathaniel Hawthorne knew what he was doing when he branded Hester Prynne with a "scarlet" letter. That color evokes images of passion and hellfire. Likewise, the expressions "a yellow streak," "a green thumb," "a blue funk," "a black mood," all convey meaning based on messages that color conveys.

The Human Response to Color

A great deal of study has been done on human response to color. Although responses can sometimes be subjective, and may vary from culture to culture, these studies provide some guidelines that can help artists control viewers' perceptions. If you know the responses colors most commonly evoke in our culture, you can strengthen your point of view and the general mood you wish to capture and express. Simply by changing the tone of a sky, you can turn a sweltering noonday landscape into a soothing cool panorama. Notice the subtle differences of mood that Jim Mc-Vicker achieves in his two paintings of the same barn.

Characteristics of Color

Experiment with colors and find out the ones that express the mood you are looking to create. Let the subject and the desired mood dictate what's best. In the illustration (right) of hue and emotional response, I have matched the colors of the spectrum with a list of their characteristics. Colors from the warm end of the spectrum (red, orange, yellow) create more excitement and energy than the cool colors (green, blue, violet), which have a calming effect. Other attributes of color—chroma, value and temperature—have similar powers.

Morning vs. Afternoon

These two images of Ferndale Barn, painted at different times of the day, project subtle differences in mood. The softer, diffused light of the early morning work provides less contrast and therefore less energy, resulting in a more soothing, restful tenor.

Ferndale Barn Morning Light, Jim McVicker
Oil on paper, 11" × 17"
Collection of Mr. and Mrs. Daniel Jacobs

Ferndale Barn Afternoon Light
Jim McVicker
Oil on paper, 11¼" × 15½"

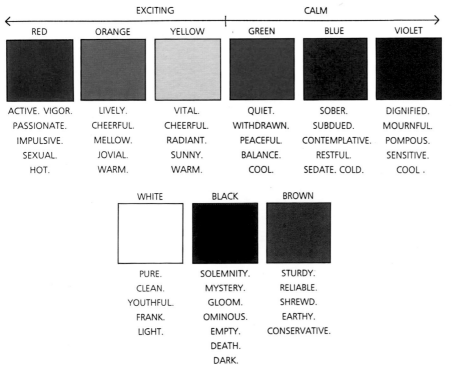

	EXCITING			CALM	
RED	ORANGE	YELLOW	GREEN	BLUE	VIOLET
ACTIVE. VIGOR.	LIVELY.	VITAL.	QUIET.	SOBER.	DIGNIFIED.
PASSIONATE.	CHEERFUL.	CHEERFUL.	WITHDRAWN.	SUBDUED.	MOURNFUL.
IMPULSIVE.	MELLOW.	RADIANT.	PEACEFUL.	CONTEMPLATIVE.	POMPOUS.
SEXUAL.	JOVIAL.	SUNNY.	BALANCE.	RESTFUL.	SENSITIVE.
HOT.	WARM.	WARM.	COOL.	SEDATE. COLD.	COOL .

WHITE	BLACK	BROWN
PURE.	SOLEMNITY.	STURDY.
CLEAN.	MYSTERY.	RELIABLE.
YOUTHFUL.	GLOOM.	SHREWD.
FRANK.	OMINOUS.	EARTHY.
LIGHT.	EMPTY.	CONSERVATIVE.
	DEATH.	
	DARK.	

Hue and Emotional Response

In general, the colors at the warm end of the spectrum (red, orange, yellow) will create more excitement than the cool spectral colors (green, blue, violet). The list of characteristics suggested by each color is just a starting point, since the "mood" of each color also depends on what surrounds it.

INTENSITY AND VALUE

We all know how bright days of sunshine and gloomy days of rain affect a person's outlook. The same is true in painting. The brighter a color's intensity, or chroma, the more energy it creates. The same is true of strong value contrast. The intensity and value illustration (below) shows how intense colors and quick color changes excite the senses, while darker or muted colors and close value relationships are more soothing. Note also how bright and dark colors, side by side, create a nervous effect that makes the brights seem brighter and the darks seem darker.

If you want a soothing painting, try the reverse: Use harmonious colors or colors next to each other on the color wheel. In the painting *In Memory Of . . .* by Judi Betts (right), for instance, the soft analogous colors create a quiet harmony that lends a peaceful, calming feeling. Low-intensity color adds to the ethereal effect. In contrast, Midge Stires's strong color and intensity excite (see painting on opposite page).

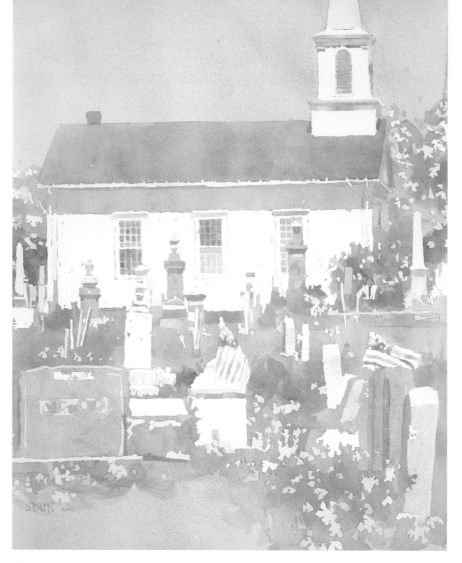

Close Values Convey Calm
The soft tones and genteel touch of Betts's watercolor convey a peaceful, calm sensation. The close value relationships also heighten this restful effect.

In Memory of . . . , Judi Betts, Watercolor, 30" × 22", Collection of the Artist

SUBTLE COLOR OR GRADUAL COLOR CHANGES PROJECT A CALM MOOD.

CLOSE VALUE RELATIONSHIPS ARE CALM.

QUICK AND INTENSE CHANGES ARE EXCITING.

SHARP VALUE CHANGES CREATE ENERGY.

BRIGHT AND DARK COLORS SIDE BY SIDE INTENSIFY EACH OTHER FOR AN EXCITED MOOD.

The Effects of Changes in Value or Intensity
These five examples are only a few of the ways you can control mood through intensity and value. Sharp color changes, for instance, make the eye almost dart into the piece; smoother areas offer a gentler lure. Excitement and calm are the end products of value and intensity.

TEMPERATURE

Remember also that there are warm and cool variations within each hue. Cerulean blue and ultramarine are both blue, but ultramarine has a cooler cast. Choose pigments that will work toward the desired mood. For example, if you are working for a calm, cool effect in a garden scene, you can use a red as an accent as long as it leans toward the cooler, violet end of the red range rather than a hot, bright orange-red. This helps control ten-sion and unifies the painting.

In planning a painting, you're confronted with an unlimited number of color, color temperature, color intensity and color value combinations. The concept of your painting should help you choose between these combinations. If tones aren't closely related, the mood will not be peaceful. Let the tools of color and your own inclinations direct your choices so that your painting says exactly what you want it to say.

Intense Hues Excite the Eye
In contrast to the mood conveyed by Betts's *In Memory of . . .* , Stires's intense hues excite the eye as we are pulled through the sandy foreground to the brilliant blue sky beyond the dunes.

June at Fire Island, Midge Stires
Acrylic, 18" × 24"

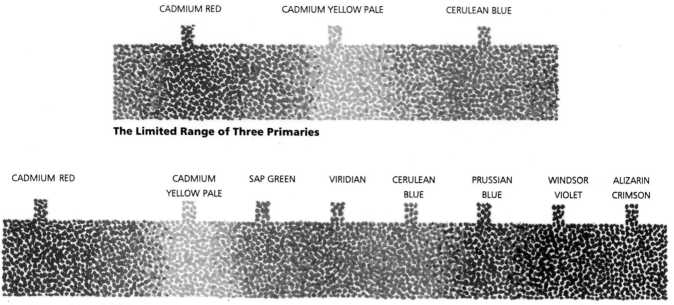

CADMIUM RED CADMIUM YELLOW PALE CERULEAN BLUE

The Limited Range of Three Primaries

CADMIUM RED CADMIUM YELLOW PALE SAP GREEN VIRIDIAN CERULEAN BLUE PRUSSIAN BLUE WINDSOR VIOLET ALIZARIN CRIMSON

The Spectral Possibilities From the Recommended Palette
In these two spectral lines we see the limited color possibilities from a palette restricted to three primary hues (top). The increased variety occurs when we begin adding colors to our palette (bottom).

CHOOSING YOUR PALETTE

Your use of color is going to reflect your unique nature. Just as an artist will have an affinity for certain subjects, a particular medium or an application technique, an artist will prefer certain colors, color schemes and color combinations. So far we've looked at how color intensifies the mood of a subject. The mood and personality of the artist will also be reflected in a work. Think of van Gogh's harsh, excited colors or the soft, soulful hues of Mary Cassatt and Edgar Degas. Think of the wildly expressive colors of Andre Derain and the light, airy colors of Alfred Sisley. Any artist may choose at some point to illustrate an apple, but the red you select may be a different red from your colleague's. Some stylistic approaches require transparent, translucent or opaque color, but you usually have complete freedom in color choice. In the earliest stages of your artistic expression, the selection at its best will seem limitless and loaded with possibili-

ties. At its worst, its variety, expense and capacity may seem confusing.

How Much Choice?

For any artist beginning color study, I recommend keeping your palette small enough to learn what the colors will do for one another, but large enough to provide you with a bright, vibrant spectrum.

Theoretically, the primaries—red, yellow and blue—are all you need. In reality, however, this is not the case, because the theories are based on the breakdown of white light, while artists' paints are made from pigments. When you mix paint, you set up different reactions that make pigment limitations obvious. For instance, if you were to choose a primary triad from cadmium red, cadmium yellow and cerulean blue, you'd find that the warm range of cadmium red and cadmium yellow would yield a very satisfactory orange. The cadmium yellow and cerulean blue, however, would yield a disappointing dull green. Likewise, cadmium red plus

cerulean blue would create a low-intensity violet. This is because both cadmium red and cerulean blue have touches of yellow in them that work to neutralize, or gray, its complement, violet. So, these secondary colors can be effective, but not in all circumstances. Brightness in these colors is best attained by adding a few more colors to your palette.

A STARTER PALETTE

I recommend a starter palette of five colors: cadmium red, cadmium yellow pale, sap green, cerulean blue and Winsor violet. I chose these because they are bright and vibrant, qualities which are always diminished in color mixing, so it's best to begin as intense as possible.

To these colors I add alizarin crimson (a cool counterpart to cadmium red), viridian (at the cool end of the green scale), and Prussian blue (a rich, dark blue), colors that provide a great deal of control in mixing strong, midrange hues. You may want to add burnt sienna: it's a hardy brown tone that may be

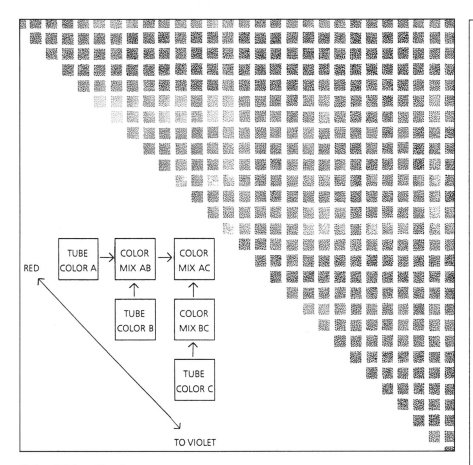

Color Mixing Chart
A chart like this one can show you what the colors on your palette can do for you. By mixing hues both from top to bottom and left to right, you can learn what to expect from different combinations on your palette. This knowledge will give you greater control over the color in your work.

richer than something you might mix.

If you are working in oils, acrylics or gouache, you'll need a white to control the value. I recommend titanium white because it's very opaque, very white, and it mixes and covers well. If you're working in a traditional watercolor technique, your paper will provide the value brightness, so white paint isn't necessary.

You may also want to purchase a black tone, although a rich dark can be created by mixing colors already listed, such as alizarin crimson and Prussian blue. You could also neutralize hues into grays by mixing them with their complements—for example, Winsor violet and cadmium yellow pale.

Through experimentation and experience, you'll quickly learn how to control this palette. At that point, you may want to add a few more colors that appeal to you on an emotional level. Over the years, my palette has grown quite large. It consists of 28 colors that cover the spectrum from red to violet. From these 28, I can mix a total of 406 different hues using a 50/50 color mix ratio. An endless number of hues can be mixed by varying the proportions of pigment, but the 50/50 ratio simplifies color mixing and provides a basis for understanding what these 28 colors can do in combination. Of course, the 50/50 mix ratio can be adjusted to achieve the desired color once I've identified the closest basic hue.

TO CREATE YOUR OWN COLOR MIXING CHART

1. Mark off a graph of half-inch squares with one-quarter inch spaces between them. You should have as many squares across the top and down the right-hand side as there are colors in your palette. Mine, for example, has 28 half-inch squares across the top and 28 down the right-hand side. Colors on the diagonal are mixed from the top left square to the bottom right square.

2. Begin painting in your palette colors straight from the tube.

3. Then, if you're working with watercolor or tempera, mix a puddle of each tube color in a slant tile or egg carton.

4. Next, mix 50 percent of color A with 50 percent of color B to achieve color AB.

5. Repeat with colors A and C using the same proportions, and so on.

6. When you've finished the entire A row, move on to mix color B with color C for color BC, continuing on to complete the B row.

Note that in my color chart I painted the squares with dots. This gives me a better idea of how a color will look when painted pointillistically rather than as a flat color. Apply your color in a method comparable to your application technique.

This process, although tedious, will help you develop excellent color control. After working with your chart, you'll see at a glance how to achieve the colors you want.

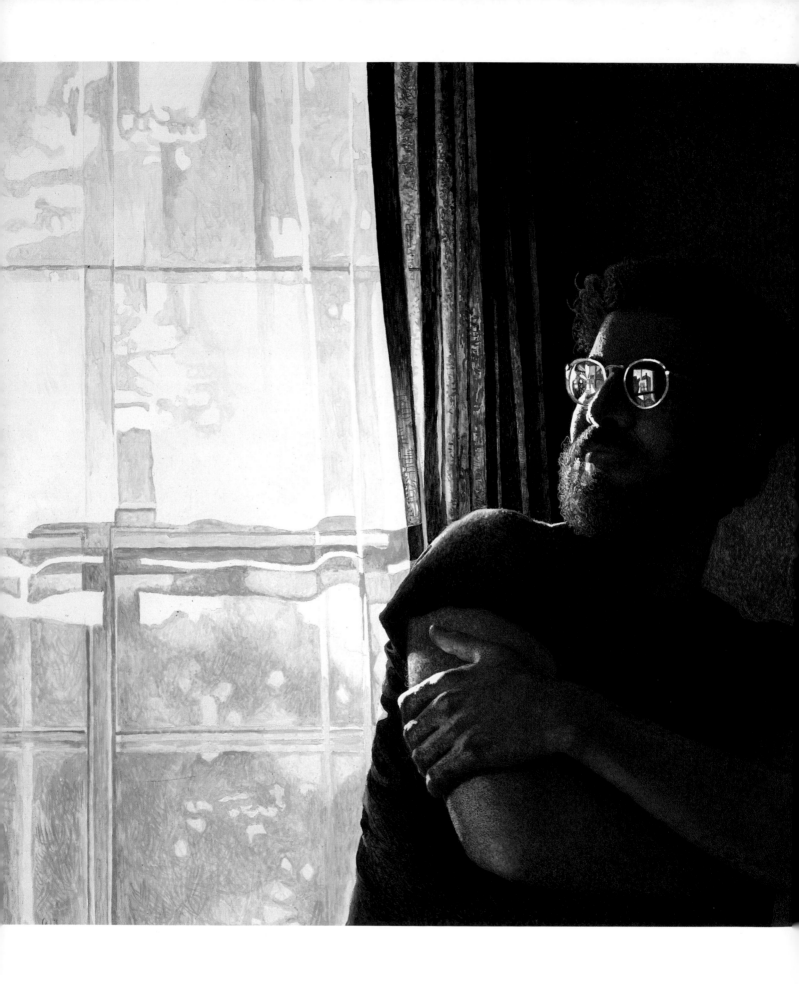

A Quick Guide to the Vocabulary of Design

H uman beings have been designing since they began expressing themselves visually. The cave drawings discussed in chapter three were a consciously planned effort to pictorially represent the hunt that was necessary for survival. They are examples of ordered thought, just as we order our thoughts into visual expression today. This process does not happen easily or by accident. It is a cognitive task that will produce an emotionally compelling image if properly structured. As we conceive of and place line, shape, value and color into an organized pattern, we build what is commonly referred to as a design. If we don't control this composition, we will arrive at a design by default. And it may not be good design.

To share your point of view most effectively, you must have a sound understanding of the principles of design, including the relationships of balance, focus, movement, space and contrast. All of these design tools can be used to integrate your basic elements into a unified work. This unity will bring a sense of completeness, a sense of oneness to the

In designing this work, Wiltraut has considered the balance of light and dark, the positive and negative space, the element of contrasting textures, a strong focal point, and subtly implied possibility of motion at any time from the figure or drape. These elements all add up to a beautifully planned and executed painting.

Looking Toward Evening, Douglas Wiltraut, acrylic, 17" × 24", collection of Mrs. Jerry Mark

REALIZING YOUR POTENTIAL

The very nature of art is illusive. Creativity is mysterious. Intuition and natural gifts in the field of design must be acknowledged. If great design could be taught, we would all paint like da Vinci or Michelangelo, but it can't — even these geniuses made unsuccessful attempts. Still, certain ideas and concepts of design can be studied and learned. Supported by this knowledge, we can push our abilities further than they might otherwise have developed. We can realize our potential, perhaps even our genius. Certainly no genius achieved greatness by ignoring these principles.

A DELICATE BALANCE

I love to watch gymnastics. The beauty and grace of this sport are thrilling examples of balance — illustrated at its best. As we watch gymnasts move across a balance beam in a series of turns, twists and flips, we fully understand that every move they make must be counterbalanced with an almost imperceptible shift in the body's weight. Should too much of a body's mass move to one side of the central axis or the other, failure and a fall are inevitable. For an audience, this shifting transforms our participation from appreciative wonder to anxiety. But if the gymnasts sustain their balance throughout their routines, their movements are not only aesthetically pleasing to watch, but they also provide us with a sense of comfort and order.

The same is true of your artwork: Without balance, your paintings can take a disastrous fall. If you don't control the physical forces that threaten the stability of your visual imagery, your work will project feelings of discomfort, disorientation and disequilibrium. We have come to expect balance in our lives and react adversely when balance is

Hostages
Daniel E. Greene
Oil, 25" × 30"
Collection of the Artist

Creating Balance
The weight of this oil painting is visually balanced; it projects an image of order and stability.

Bouquet
Priscilla Taylor Rosenberger
Pastel, 33" × 25"

Balancing Visual Weights
While the flowers may be cascading to the floor, the light and visual weight of the areas of mass are balanced; therefore equilibrium is maintained.

missing. To make sure you establish and communicate this sense of order and well-being in your design, all the weight you employ should be offset with a counterweight.

TWO APPROACHES TO VISUAL BALANCE

There are two time-tested approaches to visual balance. The first type of balance is symmetrical—a systematic construction of a very formal nature where mirror images are reflected off of a central axis. The second type of balance is asymmetrical. Here, the more informal arrangement depends heavily on feeling and experience to balance visual weight. This doesn't mean that symmetry shouldn't have its roots in feeling as well, but the symmetrical composition is by its very nature more controlled. It deserves repeating that all of these design principles should be considered as guides, not rules. They should be subservient to your needs and intents.

SYMMETRICAL BALANCE

Our appreciation of the beauty of symmetry has a long history in Western art. This appreciation may result from the mind's quest to make meaning and sense of its world, or it may have its roots in the early Greeks' reverence for the human form, one of their favorite examples of symmetrical design. The visual weight of symmetry is very compelling; it commands our attention and sustains our interest.

Pure Symmetry
Whether it is a candlestick or two faces makes no difference here. This is a perfect illustration of pure symmetry. Both halves are mirror images of each other on either side of a central axis.

Achieving a Sense of Order
Our need to bring balance and harmony into our lives is reflected in this watercolor. A symmetrical image like this one establishes a sense of order and creates feelings of comfort and well-being.

The Chalk Garden
David P. Richards
Watercolor
16" × 28"

Adaptations

Perfect symmetry, however, is seldom seen in human form and nature. Adjustments to one side or the other of your painting's axis prevent your art from becoming static and boring. In Daniel Greene's pastel painting *Susan*, the contours of either side follow similar paths, but adaptation in a few areas, such as the raised knee and the holding of the string spindle, keep the art fresh, alive and visually intriguing.

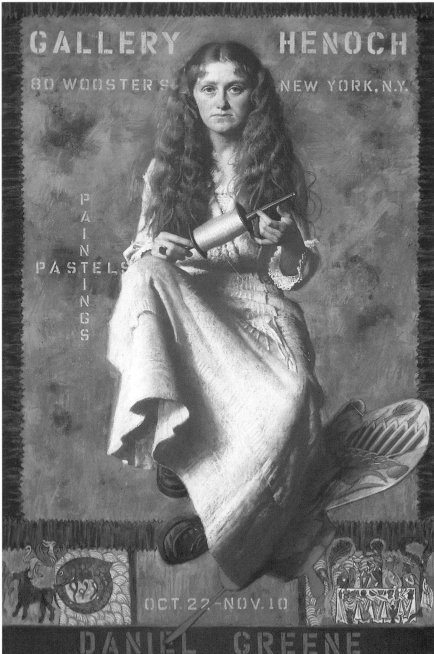

Designing Stability

This painting connects a series of triangles and rectangles that sit solidly on their bases. The design communicates stability; there is no falling weight here. While the balance is strong, the free-form line radiates light-hearted energy.

Quilt Sampler Tree/Star Quilt
Patricia San Soucie
Watercolor, gouache, acrylic 39" × 28"
Collection of the Artist

Adjusting Symmetry

Symmetry produces the illusion of equal halves. But pure symmetry is seldom found in nature—compare the two halves of a pine tree split down the trunk. In our paintings, adjustments to one side or the other will ring truer and provide a more interesting image. In this painting the raised knee and the kite spindle are just two of the variations from pure symmetry that bring increased visual interest to the work.

Susan
Daniel E. Greene, Pastel, 60" × 40"
Collection of Dr. and Mrs. Mohammed Khavari

Radial Symmetry

Another configuration of this symmetrical uniformity is radial symmetry in which the composition moves out of a mirrored vertical and horizontal. The axes here can actually be of any number as long as they rotate around or form a central point. This design formation carries the same stability and order as single axis symmetry.

Radial Symmetry

In radial symmetry, we increase the number of axes from which the image radiates. This design is well-ordered and stable like single-axis symmetry.

Designing Balance and Order

Wiltraut's painting is an adaptation of a radially symmetric design in which the focus is the circular wreath. While shadowed patterns mask the obvious symmetry, strong feelings of balance, order and comfort remain.

Friendship Ring, Douglas Wiltraut
Egg tempera, 24" × 34"
Collection of Mr. Thomas Khoury

ASYMMETRICAL BALANCE

In asymmetrical balance, the invisible axis around which a painting's balance is distributed need not be in the center of the visual field. While the total weight on either side should be equalized, the forms that provide weight need not be equal in mass.

To illustrate the physics involved, think about hanging a painting versus hanging a mobile. To find the center of balance of a conventional rectangular painting, you put one nail in the wall and hang the painting so that equal proportions are on either side of the nail. This is symmetry. To hang a mobile, however, you first find and wire the central axis. Heavy weights will need to be placed close to the axis to counterbalance lighter weights distributed irregularly on the other side. Your goal here is equally balanced weight on both sides of the axis, like a lever with equal force on each end. If you hang the mobile from the wrong axis, it will shift precariously, projecting instability. This is exactly what you are working to avoid.

No matter what your message, your goal is to draw the viewer to the image, not away from it. Use line, value or color rather than intentional imbalance to create tension or disequilibrium. A work that lacks balance—whether symmetrical or asymmetrical—will confuse and repel the viewer rather than encourage the viewer to consider your intent. A poorly balanced work is more likely to be dismissed than examined for understanding.

Asymmetry
Asymmetrical design does not conform to the static arrangement of a central axis with equal weight on either side. But the total mass of the picture is distributed to create a sense of balance within the picture plane.

Balance in an Asymmetrical Design
In Liu's asymmetrical design, the balance hangs from an axis to the left of center. The heavier weight must be closer to this imaginary axis to counter the lighter but more extended weight to the right of the visual field.

Scroll #2, Katherine Chang Liu
Mixed mediums, 30" × 40"

Maintaining Equilibrium

Mitchell's *Noon Nap* is a splendid example of asymmetrical design. The extreme weight of the seated figure mainly appears in the left half of the picture plane. However, the visual weight of the receding red flowers and detailed tablecloths provides total equilibrium.

Noon Nap
Dean Mitchell
Oil, 27" × 37"

POSITIVELY NEGATIVE BALANCE

It is important to balance all of the weight in your picture plane. Every area comes into play. Larger neutral shapes lend stability to smaller, more focal ones. Backgrounds and negative spaces have weight of their own as well; they counteract foreground action and positive figures. Consider the spaces between and behind your subject. As you can see in Katherine Chang Liu's painting *Scroll #2* (left), the large open space provides the balance on which the work's success depends. Notice also the wonderful form that Dean Mitchell has created in the space that surrounds his figures in *Bonding Years*. This shape has an abstract interest all its own.

For unity in your composition, pay attention to all of your weights.

Designing the Background and Negative Space

When you consider your composition, plan the area around your subject as well as the subject itself. In this characteristically clean Mitchell composition, the focus is on the figures and the light falling upon them. However, the shape "designed" around the figures has an interest all its own.

Bonding Years
Dean Mitchell, Oil
39¹³/₁₆" × 29¹³/₁₆"

CONTRAST, CONTRAST, CONTRAST

There are so many interrelationships at work in a finished painting that it is hard to look at any of these forces in isolation. They are all intermingled and connected. However, one connection stands out as vital: the relationship between balance and contrast.

In talking to many of the fine artists whose works are reproduced in this book, I would say that the one principle that came up most often in our conversations was contrast. Contrast and balanced opposites add interest and energy to a work. Contrast also helps us simplify our design by saying more with less. By effectively controlling every area of our picture plane, nothing superfluous is added. We can create excitement and capture

attention more quickly by manipulating contrast than by any other means. Would William Gorman's *British Series: Red Landscape and Abbey* (below) be so effective if the strong and stately architecture were not contrasted with the ethereal currents of time?

Contrasting Texture, Line and Value

As we saw when looking at simultaneous color sensations, contrast heightens differences. Neighboring areas will sharpen the delineations of one another. We have all heard stories of movie actors who insisted that less attractive actors be cast in supporting roles. The principle of contrast increases the beauty of the leading lady or man. By the same principle, a smooth object in your painting

seems smoother just by being juxtaposed with rough textures. In William Persa's watercolor *Pop's Jacket and Three Red Apples* (right), for example, the ragged denim, the firm fruit and the crumbling wall all complement each other. Variations within one area will intensify the differences of neighboring areas. Serge Hollerbach's bright horizon in *Pier at Myrtle Beach* (below right) is intensified by darkening or subduing the surrounding space. A thin graceful line is even more so when it is in the presence of a heavy cumbersome line.

The array of contrasts at your disposal is unlimited. By knowing just what you want to say in your painting, you can look to contrast for a helping hand.

British Series: Red Landscape and Abbey
William D. Gorman
Casein, 22″ × 30″
Collection of Cary Shott

Contrasting Forms
Interesting contrast can become a part of your art in any number of ways. In Gorman's painting, forms contrast. The solidity of the stately ruins contrasts powerfully with the ethereal waves of air that surround them.

Textural Contrast
Persa employs textural contrast to capture our interest in his watercolor. The worn denim jacket, the crumbling cement wall and the smooth, firm fruit set up a visual comparison that is a pleasure to contemplate.

Pop's Jacket and Three Red Apples
William Persa
Watercolor, 26" × 36"

Contrasting Tones
Contrast in Hollerbach's watercolor is established through color. The otherwise dark and subdued tone of the rest of the picture lights this lively sky even more dramatically. Without contrasting darks, this effect could not be achieved.

Pier at Myrtle Beach, Serge Hollerbach
Watercolor, 10" × 14"

73

Contrasting Images

Painting relationships can leave psychological impressions as well as aesthetic sensations. Juxtaposing images of social, moral or political concerns can be very effective. In James DePietro's oil painting *Fragment Series: The Hidden* the thorny stem beneath the beautiful surface of the roses suggests DePietro's theme: the hidden danger. Not everything in a bed of roses is beautiful; contrast helps DePietro say this.

Contrasting Direct Opposite

Direct opposites provide the most compelling contrasts. This was seen in the color wheel work, in which complementary colors used concurrently caused the most striking sensation. So, the use of black against white, or flat against three-dimensional, or a singular object against a crowd will help tell a clear tale. But you can see contrast in similar objects or sensations as well. In fact, any relationship, regardless of the degree of contrast, invites comparison. If you are working on a piece and decide that more contrast is necessary in adjoining areas, you need only ask yourself what areas you want to stand out and by how much. Then you can adjust texture, value, color, line shape, edges and so on to bring greater meaning and focus to the area you want to enhance.

A Lively Comparison

Moore's comparison of human and cardboard figures is another example of contrast. If the viewer were unable to consider one and then the others, the visual impact of this painting would be diminished. As it is, contrast increases the human quality of the man as well as the two-dimensionality of his bovine friends.

Getting the Farm Life Nailed Down
Scott Moore
Watercolor, 20½" × 34¾"

Conceptual Contrast

In DePietro's painting, the conceptual contrast of the hidden thorns in a field of soft, velvety roses stirs the mind of the viewer. It is this contrast that makes us weigh the possible dangers in an otherwise inviting situation.

Fragment Series: The Hidden
James DePietro
Oil, 36″ × 30″
Collection of Charles McAnall

FOCUS

Occasionally, you will watch someone enter a room and see all eyes turn toward him or her. Whether silhouetted in a doorway or floating down a staircase into a still crowd, this person commands attention. In politics or show business, this attribute is called presence. In art, this same principle of establishing a focal point can be an effective tool to enhance your point of view.

As you design your work, certain elements will have a more positive impact than others and should take precedence. You can control your audience's visual response by using specific techniques and devices just as the person with presence manipulates the audience's view by using fashion and attitude. Focus emphasizes what is primary over what is secondary. In controlling focus we rely on visual weight, which can be physical or psychological and which depends on contrast.

Black and White Contrast
Contrast plays an important role in establishing focus. The stronger the contrast, the greater the focus. Few contrasts are more striking than that between black and white.

Scraps, Denise Luhman
Acrylic and oil, 9″ × 12″

Keeping the Focus in Check
Focus also adds believability to Moore's fantastical visions. Here, he angles the objects to lead the viewer into the focal areas and also designs the light and shadow patterns to draw attention there.

Grocery Checkers, Scott Moore
Oil, 37″ × 42″, Private Collection

Focusing With Weight

In many cases we are drawn to a focal point of compelling physical contrast. Consider mass—pure and simple. What stands out, as a general rule, is what doesn't blend in. When given the opportunity, large shapes will capture our attention first. Consider Laurel and Hardy. Laurel looks thinner and Hardy heavier through contrast. This contrast intensifies the differences between the partners and emphasizes the humorous appearance of the team. Purely from a bulk standpoint, we are drawn to objects by their weight, but in a field of otherwise large figures, a small one will become focal.

The focus then is on the exceptional. If a person of presence happens to be a six-foot, five-inch fashion model, height alone would say to us, "Look." That person would stand out in a crowd purely by virtue of contrast with average height. Without this sense of contrast, the person would cease to have such a visual impact. Without the secondary focus of people of lesser height, size loses meaning—through lack of comparison.

If you were to paint the model, you could only communicate the above-average stature through a composition that included people of average height or through some similar size comparison using objects of familiar dimensions.

Contrasting Physical Weight

In this painting, we are at first drawn to the mass of the mountain purely because of its commanding size. This huge presence is further emphasized through its comparison with the buildings in the foreground.

Mining Town, Frank Webb, Watercolor, 22" × 30"

Blueberry Squares
Frosted
Patricia San Soucie
Watercolor and
gouache, 22" × 30"
Collection of the
Artist

Primary Focus Is Largest Mass
In San Soucie's painting, the blue-violet configuration in the lower-right quadrant takes on a primary focus because its mass, pure and simple, stands out over the rest of the work.

The Area of Greatest Impact Can Be Small
Small areas in a painting can be focal. In this work, Stires draws us to the church steeple, which is perhaps the smallest element in the piece. The steeple's sharp, geometric architecture against the soft, natural shapes of the land and its contrasting stark white in an otherwise green field draw us through the sweeping panorama to a place of visual rest.

View From Topsmeed, Pottersville, NJ
Midge Stires, acrylic, 18" × 22"

Focusing With Color

I considered size first because it is so obvious, but any contrast can focus our attention. Under a Christmas tree, we often see the largest gift first. If two large packages wrapped in a matte gray-green paper of a hue similar to the tree are placed next to a smaller package wrapped in bright red foil, the smaller mass will become focal. It has greater visual weight through comparison.

Consider our person of presence again. You might assume that a red outfit would be focal, but what if everyone else were dressed in red? Then a bright cobalt blue would be more eye-catching. How could the person generate the greatest impact in a yellow room? By wearing a purple outfit, because complementary colors offer the greatest contrast.

Focus by Color
The obvious addition of intense color to an otherwise soft, almost colorless composition will create strong visual pull and focus.

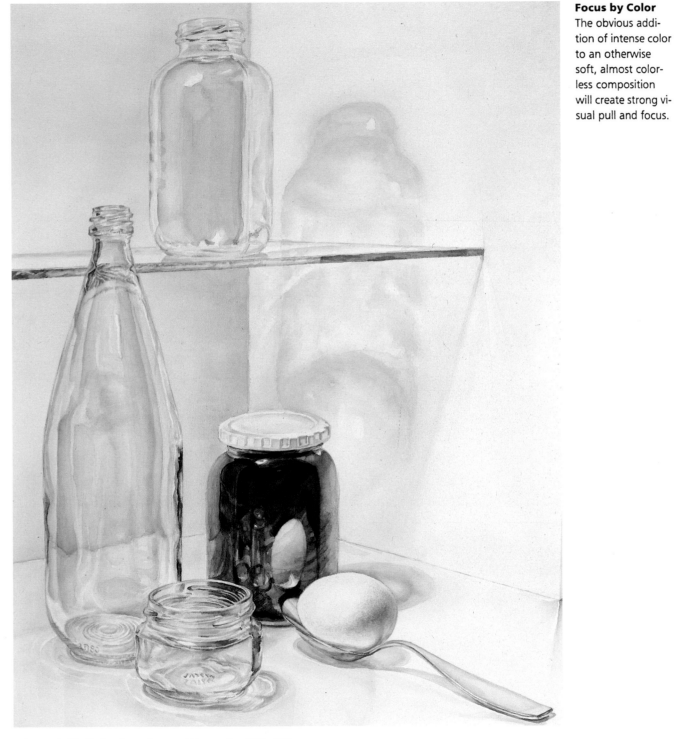

Glass, Priscilla Taylor Rosenberger, Watercolor, 20" × 26"

OTHER FACTORS AFFECTING FOCUS

Size, value, color, line clarity, complexity of shape, implied movement—any of these factors might provide the contrast that directs attention to the heart of a painting. In the section on value, we looked at extreme contrast in Douglas Wiltraut's painting *Swept Away* (page 41). Wiltraut not only establishes drama and mystery, he also establishes focus in that dark region. Taking this value contrast a step further, Richard Pionk's *Apples and Grapes* (below) all but obliterates the surrounding space in darkness, focusing intensely on the objects that remain.

All of our basic elements can be manipulated to establish focus. Earl Grenville Killeen uses line. Because his subject matter in *Interstices* (page 81) is composed of

FOCUS BY SIZE

FOCUS BY VALUE INTENSITY

FOCUS BY EDGES

FOCUS BY MOVEMENT

Summary of Factors on Focus

In this illustration we see how focus can be dictated by (a) size, (b) value intensity, (c) edges or (d) movement.

Focus by Value

As we saw in the chapter on value, extreme dark spaces recede. This moves the lit surfaces forward, making them focal. Our attention is further drawn to the areas of most dramatic light—in this case, the bowl's interior.

Apples and Grapes, Richard Pionk
Oil, 24" × 24", Private Collection

straight horizontal and vertical lines, any element that interrupts the perpendicular flow, like the doorknob or lock plate, becomes the focal point.

Like simpler contrasts, modifications in patterns or perceived relationships will pull attention to a particular area. In Richard Hamwi's cut paper collage *Remembrance* (right), adjustments in the color shapes and rhythm draw us to the top of the canvas. The pattern deviation responsible for this focal change is established in the larger bottom portion of the work.

Focusing on the Location of Change
Adjustments in the rhythm and flow will draw the viewer's attention to the location of the change. In this watercolor collage, the breakup of the tight pattern at the top of the work will focus our attention there.

Remembrance, Richard Hamwi
Collage, 24" × 24"

Focus by Line
Because Killeen's subject matter is composed of straight vertical and horizontal lines, the focal point is either at the point of intersection of these lines or at any element that interrupts the perpendicular flow.

Interstices, Earl Grenville Killeen
Watercolor, 9¾" × 12¾"

Focus With Symbols

Recognizable letters and words become instant focal points because of the meaning they carry for the viewer. These symbols are easily deciphered and therefore provide a sense of understandable order and a place to enter the painting.

Door, Katherine Chang Liu, Mixed mediums, 18″×36″

Figures Are an Instant Focal Point

The addition of the "human element" to a painting will create another instant focal point, because as human beings it is easy for us to relate to the human figure. This painting is a great demonstration of this concept because the construction workers—the human element—are so small in relation to the entire work's inanimate subjects, yet so compelling.

Construction, Irwin Greenberg, Watercolor, 11″×14″, Courtesy of Wyckoff Gallery

Psychological Weight

Relationships among composed components also catch the eye. Any form physically isolated from a crowd of forms, for example, attracts and sustains attention. This isolation might also connote the psychological weight of separation, independence or loneliness, which would only serve to intensify the focus.

As viewers we are visually drawn to areas of perceived psychological weight much as we are to physical weight. Different relationships carry different psychological weights. Consider Marc Chagall's surprising image of a couple rising in space as they kiss. Even against a striking red ground, our eyes are riveted on the two swept-away figures. The figures would be less striking if they were just kissing on a bench. The sensation of soaring associated with passion gives great weight to this focus.

The Human Presence

The human element alone draws us in and holds us. We are so intrigued by the human experience that any figure placed in a painting instantly becomes the center of interest. Irwin Greenberg's watercolor *Construction* is a perfect example of this principle. Even though the figures are soft and cloudy and poised against a massive construction sight, our attraction to them is irresistible. The additional implied activity of the workmen increases our interest, as action and movement carry more visual weight than passivity.

IMPLIED ACTION

The type of movement I am refer-
ring to in this case is the illusion of
implied action within the picture
plane. You can use several graphic
approaches to achieve this visual
representation of the passage of
time, which transforms an image
from a frozen moment to a dy-
namic impression.

The Unstable Edge

One such approach is to use a
blurred or unstable edge. We have
come to expect acuity in our visual
encounters, and when we don't
find it, our brain tells us something
is happening. That something is of-
ten movement. Oliver Rodums
uses this effect beautifully to speed
his figures and shapes through
time. In his painting *Time Depar-
ture* (below right), Rodums uses
the contrast between some blurred
edges against other more well-de-
fined edges to tell us where the
greatest movement occurs. Similar
to blurred edges are overlapping
images and trail lines. These tech-
niques, which are common in
comic strips, can be just as effective
in painting.

An Isolated Figure Attracts Our Attention

We are drawn to the human element in Mitchell's *Weston Corner* (above) as we are in
Greenberg's *Construction* (left). In addition to this natural attraction, the isolation or segre-
gation of any lone form or figure from an area or crowd carries strong psychological weight.
So, Mitchell's figure as a focal center is doubly attractive.

Weston Corner, Dean Mitchell, Watercolor, 14" × 18"

Implied Movement

The implied movement of the small white
form at top center is signified by its blurred
edges and elevated placement. This sense of
movement gives it predominance over the
other still spacescape shapes.

Time Departure, Oliver Rodums
Oil, 52" × 50"

Thomas Pond Rocks, Charlene Engel, Serigraph, 22" × 26"

A MOVING EXPERIENCE

Another type of movement, entirely different from implied action is the path of viewers' eyes as they scan a work of art. This is another principle of design that is very important to a painting's unity. It's like a subway system within a large city. It allows us to travel freely throughout a restricted perimeter, making all of the environment a part of the whole. As we travel to our destinations — or focal points — we move in an orderly progression. This push and pull should provide a continuum of motion that keeps the spectator within the picture plane while allowing exploration to any and all areas of the work.

Following Negative Spaces
The open weave of an approach like Engel's allows for a great deal of movement as the eye threads itself through the intentional negative

A Sensation of High Energy
The path we follow here swirls around a central point as well as spinning and flying off in all other directions. But its balanced mixture of order and chaos holds us within the picture plane while constantly moving us about.

Chime
Richard Hamwi
Collage, 36" × 36"

A Line to Follow

This movement is generally thought of in terms of lines. These can be subtle or obvious paths of imaginary or real lines, and you should consider them while planning and executing your design. These are not always lines of action, but often a path the viewer's eye will follow.

What will get the eye moving? Turn back to the color illustration on intensity and value on page 60 and note how differently each combination leads the eye through the work. The epitome of static passivity is the center horizontal line or a dot placed on this horizontal line where it crosses the central vertical line. Any shift from this point will get movement started. If we move our dot to the upper-left corner of the picture plane, as we see in William Gorman's painting *Newgrange Series: Two Kerbstones*, the eye will draw its own line to follow it.

As the straight horizontal begins to tilt in one direction or another, it establishes a dynamic that pulls the viewer's eye along. If the width of this line varies from one end to the other, the eye will move along the line beginning at the end with the greater mass and traveling to the lighter end. We use such clues to tell the viewer which way to travel.

Converging lines also create this effect as the viewer's eye moves toward the point of convergence.

Horizontal Movement

The placement of Gorman's sun sphere moves us to the upper-left corner of this work. Then we move back down and across to the right via the strong horizontal.

Newgrange Series: Two Kerbstones, William D. Gorman, Casein, 22" × 30"

Diagonal Movement

A strong diagonal line, or collection of diagonals, will establish more movement than a static horizontal or vertical line. This is because we perceive this formation as unstable and are waiting for the eventual fall.

Pastel Stripes, Denise Luhman, Acrylic and oil, 8" × 10"

Moving Along a Z Path

In this watercolor, I used one of the most common and effective line movement designs, the Z or reverse S pattern. This formation is quick moving and leads the viewer's eye from the upper left to the lower right in one smooth flow.

Poppies Near Salisbury, David P. Richards
Watercolor, 10½" × 6"

Converging Lines

McVicker's use of converging lines encourages movement as we are invited to walk down Singley Road from the entrance in the foreground, through the middleground, and into the deep space of the background.

Singley Road, Morning Light, Jim McVicker
Oil, 24" × 48"

Directional Arrows

Another, more obvious way to manipulate the viewer's visual attention and movement is by planting directional arrows. As spectators, we always look where another person tells us to look. Our eyes turn automatically to where others are looking. So, just by having a figure or group of figures look toward a common spot, you can create movement and focus. A pointing finger works in much the same way. This type of directional signal can be a very effective mover.

Directional lines can bring something more to a finished work of art. As seen in the chapter on the vocabulary of line, emotional and psychological reactions are induced by the very tilt and direction of a given mark. Lines that direct eye movement can have a similar effect on mood. Whether you hope to convey a sense of serenity or frenzy or conflict, you can support your intent with this powerful and unifying design device.

Directional Arrows Create Movement

In this painting, we look to see what others in the painting are looking at and this carries us from one area to another. "Line of vision" is a great tool to point up focus.

Cross Section, James DePietro, Oil, 48" × 48"

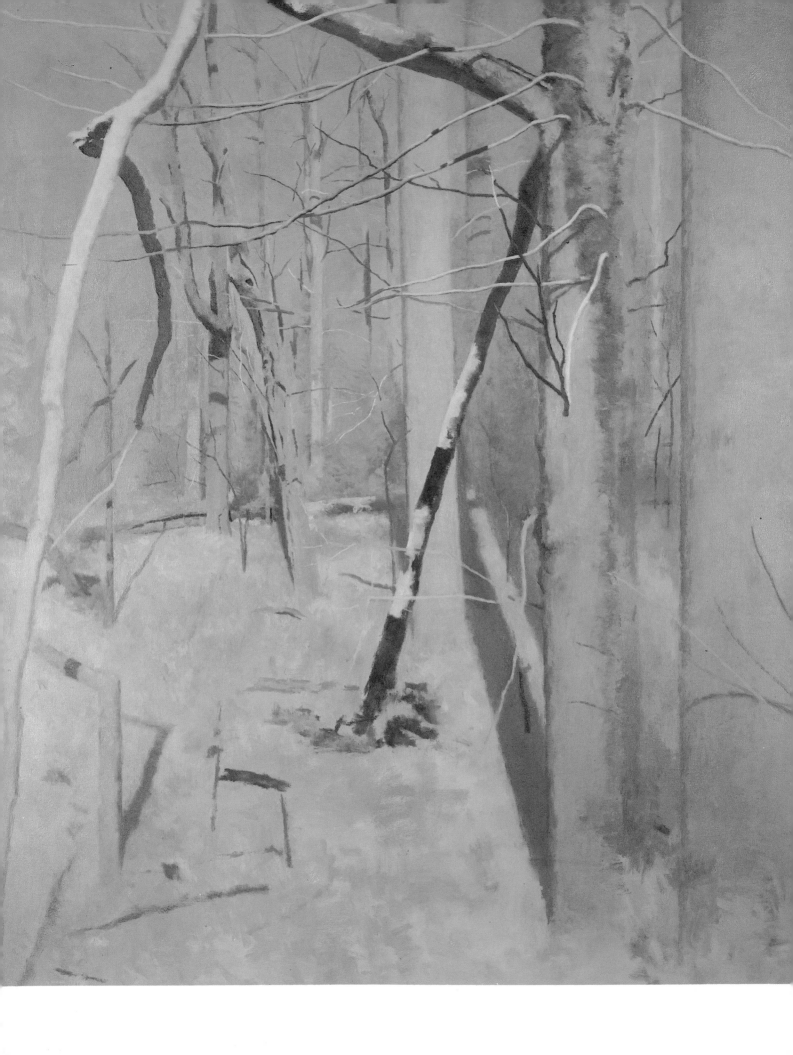

That Certain Style

Painting and drawing are almost always a solitary activity. They are seldom, if ever, done in collaboration. In the intimate world of visual expression, you have no one to answer to but yourself. You succeed on your own terms. This is one great advantage to a solitary act. One disadvantage, however, is that no one can show you exactly how to get to where you want to go. You must find your own way.

The road to successful self-expression is, for the most part, a matter of trial and error. There are no predetermined or preformulated approaches to solving problems. As you move from apprentice to full-fledged master artist, you must pack up your basic knowledge and venture forth.

It is not an entirely new path — you have already taken the first steps. But it is a private adventure, a personal journey of artistic self-discovery and self-actualization. This effort culminates in the development of a certain "look" — your own uniquely accomplished style.

Your art is as much a question of *how* you paint as *what* you paint. And style addresses the "how." Finding this style is not a matter of doing what's right or wrong. It's more a question of what's right or wrong for you. Your art will reflect your insights, your sensibilities, your fundamental nature. It will say, "I made this statement and it's unlike anyone else's."

The way you choose and combine your mediums, basic elements, principles of design and point of view will give your work a "look" that speaks for you as an artist. It won't happen the first time you pick up a brush. But it will happen — one day all of your efforts fall into place.

A personal way of seeing and a means to express that vision are at the heart of an artistic style. Schnore's beautiful forest interpretation is unlike anyone else's. His synthesis of technique, subject and point of view culminates in a unique work of art.

. . . formerly "Persig's Stroll," Peter Schnore, Oil, 57" × 48"

A Unique Style

Years of experience and dedication provide artists with ''a look'' to their work. This look says to the audience that this is an expression from the brush of Frank Webb and no one else.

Port Clyde, Frank Webb, Watercolor, 22" × 30"

Style Just Happens

''Sometimes it's midpainting, other times it's midcareer when you finally realize that what you're accomplishing is a lot more interesting than what you've been aiming for,'' says the artist.

Still Life With Plant Life
Anne Bagby
Watercolor
48" × 48"

THE BIRTH OF A STYLE

I appreciated what Anne Bagby had to say on the subject of style:

Sometimes it's midpainting, other times it's midcareer when you finally realize that what you're accomplishing is a lot more interesting than what you've been aiming for. For years I'd been frustrated that I couldn't paint directly what I wanted. I'd go over areas many times, lifting color and applying it again in a constantly evolving process. While this was hardly the answer to direct effects, I noticed that the process gave my paintings something better—an interesting patina. It put richness and nuances into the image that a more direct approach wouldn't have offered. I added even more interest by including another medium: acrylics. The dullness of the flat acrylic made the watercolor look more beautiful and alive. And so I was hooked.

Hooked and on her way to a unique style. I think this statement makes a critical point about the birth of style: It isn't something that you can consciously plan to develop; it is an end result, a physical manifestation of your combined experiences and dedication to visual expression. A body of work will eventually be connected. But this look cannot be borrowed, forced or manufactured, or it will surely be untrue. Developing your style requires a combination of patience, hard work and faith.

THE MEDIUM IS THE MESSAGE

One of the first decisions we make as we begin painting is between mediums. There are many options—pencil, charcoal, watercolor, tempera, collage, oil, acrylic or printmaking, just to name a few. The reasons for choosing a medium vary. The important thing is that you eventually discover the medium that best suits you and what you want to express. Constraints you've never considered, such as allergies, space considerations, finances or lack of ventilation may come into play. But if you devote yourself to watercolors just because you began painting in a class taught by a watercolorist, you may fail to make those necessary forays into other mediums that are new to you and be left painting for a lifetime in a fashion that does not tap your full potential.

A Vote for Conté
Reinbold's choice of conté, a semihard chalk of fine texture, is perfect for wiping and extensive erasure, which is the way he likes to work.

Memory of Walter, David Reinbold, Conté, 16½" × 15", Courtesy of Capricorn Galleries

Working With Pencil
Different mediums offer different artists different advantages. Kacicek finds that graphite pencils offer a lustrous, pearlescent, silvery quality that works well in her paintings.

Aphros, Barbara Kacicek
Graphite and watercolor, 13" × 19"
Courtesy of Capricorn Galleries

Some Advantages of Watercolor

Watercolors introduce a full range of hue. When Hollerbach is working on location, watercolors are easily transported and require few additional supplies.

City in France
Serge Hollerbach
Watercolor, 7" × 10"

Pastel Pluses

For Pionk, pastel is an immediate medium. It doesn't require much preparation, so he is free to begin while his inspiration is fresh. He also sees its beauty as immediate in that it doesn't need to be built up and requires no drying time.

Young Girl, Richard Pionk
Pastel, 24" × 19"
Collection of the Artist

The Benefits of Egg Tempera

For Wiltraut, egg tempera is a resilient medium that works like a "light trap." It holds light within and also reflects light through the pigment. Experimenting with new and untried mediums often opens exciting new doors.

Upstairs, Downstairs, Douglas Wiltraut, Egg tempera, 51" × 35", Collection of Raymond and Thelma Holland

Geranium, Jane Conneen
Etching, 2¼" × 2¼"

Mixed Mediums for an Individual Look

Mixing mediums is the choice of many artists. Conneen's work *Geranium* is a combination of etching and watercolor. Other artists represented in this book—David Cerulli, Katherine Chang Liu, Denise Luhman and Patricia San Soucie—also combine mediums to create a very individual look.

Geranium, Jane Conneen
Hand-colored etching, 2¼" × 2¼"

Making a Transition

For the last decade, I have worked mainly in watercolor. I love the medium. I love the soft, transparent, ethereal look of the finished work. But there were also times when I was frustrated with the limited saturation of color. I felt there were certain subjects that called for greater depth of color than I was able to achieve using watercolors, so I experimented with oil. I loved the smell of it and the way it could be pushed around on the canvas. I was intrigued by the way painted areas could be obliterated with successive layers. Quite

frankly, I loved the sense of freedom and spontaneity that accompanied it. Coming from the school of watercolor, I had never experienced these luxuries. Oil also had that intensity of hue that I wanted to experiment with. Painting with oil was a totally different experience.

To make the transition a little easier, I worked with the same colors I had used in watercolor paints. I have for a long time used Winsor and Newton pigments, and they offer comparable color choices in both mediums. There were, of course, some necessary adaptations

in this area, but for the most part, my mixing experience translated readily to this new medium.

My studio took on a new look. Where I had once painted on a slanted drafting table while seated, I now stood in front of an easel. I would paint and then back away from my work to consider what I had done. My approaches and my work were changing. The first physical change I noted was the size of my canvases. They were getting larger, because the way I was painting almost dictated this increase in size. This was very rejuvenating.

My supplies also changed. My

Finding the Right Medium

McVicker finds multiple delights in the oil medium. It is rich in color, it can create a variety of textures, it is very luminous, and it offers great flexibility in application techniques. Finding the medium that is best suited to an artist's nature is an important personal decision usually based on trial and error.

Daniel's Garden Shed, Jim McVicker
Oil, 22" × 30"

brush width increased to produce a larger dot. In some cases, dots became slashes. Eventually I tried acrylic pigments and other mediums that were totally new to me and that led to further changes.

The experience brings to my mind the old adage, "If our beginnings but knew our ends." The point is this: If I hadn't shifted mediums and experimented with the unknown, my work may not have grown in new directions. I now consider myself fortunate to have skills in multiple mediums and application approaches.

Maintaining a Style

Changes in medium do not always lead to new painting approaches. James DePietro has long worked in a very linear technique. His "look" developed because he began making art with colored pencil; a close network of hatch strokes was a natural result. When he decided to increase his versatility and took on the challenge of multiple mediums, he consciously retained his method of application. The hatch marks effectively conveyed his visual message, and he did not want to lose that effect. Today he enjoys the variety and flexibility that a multiple medium approach affords. But, while each medium has a somewhat different appearance, his style remains recognizable.

Discovering Possibilities

Try as many different products as you can. Don't hesitate to employ them in unconventional ways. A medium is a tool—a means to a visual end. The best tool will do the best job. Through experimentation and familiarity with different mediums and different approaches within each medium, you may discover new and unique possibilities.

London Series: Shelter, James DePietro, Colored pencil, 22" × 30"

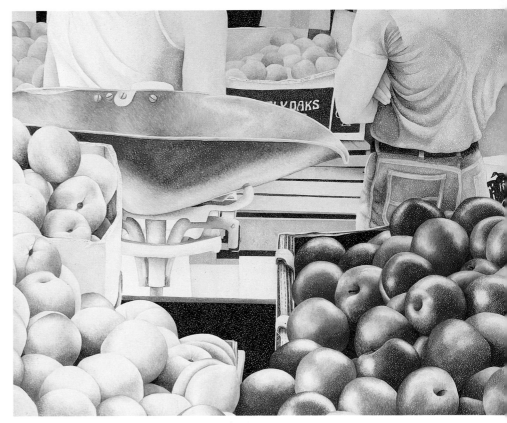

A Similar Approach to Different Mediums
Regardless of his medium, DePietro's application demonstrates the readily recognizable linear approach that he has employed for many years. As an outgrowth of his early colored pencil art, he has gone on to use this style in printmaking, acrylic and oil.

Over the Counter, James DePietro, Oil, 32" × 36", Collection of Charles Levine

BRUSHWORK

As you apply medium to a canvas or paper, it will take on a texture. The way you physically build your painting—the strokes, the boldness or lack of it, the neatness or spontaneity—works to establish this texture. And it is a texture indicative of the artist's hand.

Evidence of the Artist's Hand

I've had some interesting conversations with artists as to whether or not they like their touch to show in their work. There are two schools of thought. Artists of the first school argue that the viewer's focus ought to be on the image, not the paint quality. These artists see brushwork and gesture as distractions. They want the viewer to have an immediate response to *what* they say, not *how* they say it. To them, texture and technique should be secondary at most and perhaps it is even better if they are completely unnoticeable.

The second position argues that brushwork and gesture are an artist's signature. Proponents of this view believe it's important to see the artist's hand. They would argue that *how* artists say what they say is critical to the message, enhancing

Attention to Subject

A work of art devoid of the artist's hand will focus immediate attention on the subject being portrayed. Here, McVicker's brushwork is all but invisible through intense work and layering. For him, the inclusion of visible gesture depends upon the subject at hand.

Red and White Rhodies, Jim McVicker
Oil, 24" × 18"
Collection of Mr. and Mrs. Daniel Jacobs

Expressive Gesture

For Kessler, expressive gesture and form are fundamental to his work. The markings and visible pulls are an integral part of each piece and are extremely important to the overall effect of the finished painting.

Untitled, Michael Kessler, Acrylic on paper, 14" × 22"

and emphasizing the content of the painting.

ESTABLISHING TEXTURE

Whether you choose to *emphasize* gesture or not, you will definitely be establishing a texture of some sort, and this touch gives an inner life to a work of art.

The importance of texture is evident everywhere. Imagine for a moment that all fabric looked alike or that all food had the same consistency. There would be little individual character. Different textures stimulate our senses and provide satisfaction and pleasure of their own. This is the case in life *and* art.

Every time you apply medium to paper or canvas, you set up a decorative pattern or visual texture across the surface of the picture plane. Just as no two people have the same handwriting, no two artists apply their medium in the same way. Some paint application techniques are more pronounced than others and therefore create a more obvious textural effect. We can see this in the illustration below. An artist's choice of materials and application is the key to these stylistic effects.

 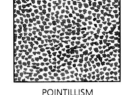

HATCHMARKS POINTILLISM FREE-FLOWING LINE VARIED-WIDTH BRUSH FLAT SOLID

Different Paint Applications Create Different Surface Feelings
Step back from your brushmarks and notice them as texture. As individual as handwriting, each brush style has a different textural feeling. Observe the difference between the controlled activity of pointillism and the dynamics of the varied-width example.

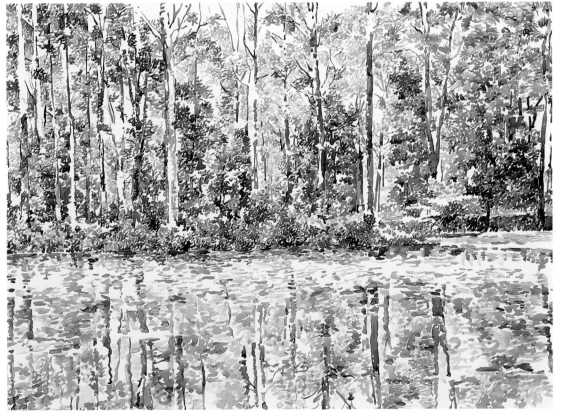

Botanical Garden
Charlene Engel
Watercolor
22" × 30"

Open Weave Approach to Texture
In this watercolor, Engel establishes a unified textural surface across the whole work. This pattern creates an underlying abstract repetition that pulls the viewer through the work. Regardless of subject, color or value, Engel's application transforms a flat surface into a patterned surface through which the eye can weave.

Different Textural Impressions

Engel's broad strokes, De-Pietro's tiny hatch marks, my own pointillist dots, Frank Webb's watercolor washes over large areas of flat mass and weight—all of these application techniques have this in common: Texture is created as the medium is applied.

By modifying this texture slightly throughout a painting, you can enhance the rhythm, focus and sensory appeal while maintaining an individual look. Within the same canvas there are many ways to heighten texture. You can control the density by opening and closing the weave, varying the length, size, shape and direction of the strokes, or combining brushwork with other gestures, such as finger work or flinging paint.

Personal Texture

Both of these paintings are rendered in watercolor, but each carries a very different textural quality. The static calm of my pointillism and the expressive freedom of Webb's wash are just two samples of the seemingly limitless approaches to personal texture.

Volcano, Frank Webb, Watercolor, 15″ × 22″

Double Illusion: Across Paris Skies, David P. Richards
Watercolor, 27″ × 40″, Collection of Stefanie Field

Impasto

With oil and acrylic paint, you can actually build up the surface texture three-dimensionally; this is called impasto painting. In impasto, you apply the paint so heavily that you create a relief surface that can be seen and felt with the eyes. You can actually build up the paint to help form the shape of the subject itself. Tension is established in impasto work by using high and low areas side by side. And isolated areas of impasto can move an object forward, while thinner, flatter areas will recede.

You can use sand or other additives to thicken or change its texture. Other elements, such as the nature of the painting surface and the spring or firmness of the instruments used, will contribute to textural impression. All of these factors converge in a personal approach that causes a viewer's senses to respond.

Acrylic Underpainting for *Mahoning Valley Road*

Mahoning Valley Road
Edith Roeder
Oil, 24" × 16"

A Two-Step Process
Roeder's finished impasto painting style begins with a fully rendered acrylic underpainting (top of page). She began using this two-step process because it provided a better map than a simple line drawing. It also helps her to lay in a quick oil top coat that isn't reworked or adjusted and therefore retains a fresh, clear color.

DUE PROCESS

Everything you do throughout the process of building a painting will contribute to its "look." The decisions you make, from conception to completion, will dictate its style.

You may develop a routine that goes with you from piece to piece. This will often assure a successful end product, since potential kinks in the process can be eliminated in prior steps.

Color Sketch and Value Studies

Judi Betts plans her watercolor paintings very carefully. She starts with a quick color sketch that helps her make an immediate choice in color dominance. Then she redoes this sketch in value studies, often as many as three, until she is satisfied with the value relationships. When she begins the actual painting, she first draws her established images with a soft lead pencil and then builds up her layers of paint.

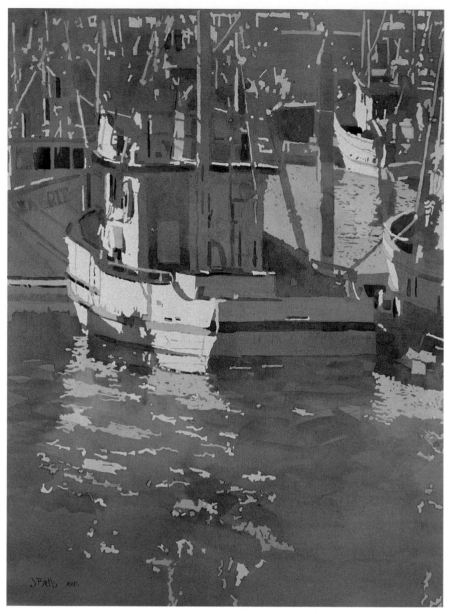

Value Study for *Sea-Esta*

Utilize Preliminary Stages

Betts likes to leave at least one third as white paper. So, when the creative process begins, she plans her paintings very carefully. She follows up a preliminary color sketch with as many as three value studies of black paint on watercolor paper. When she is satisfied with her finished design, she begins the actual work.

Sea-Esta, Judi Betts, Watercolor, 30" × 22", Collection of Mr. and Mrs. C. Robert Potter

Paper Mock-Up

David Cerulli also uses a multiple-step process to complete his three-dimensional painting constructions. To assure himself that his concept is fully realized and therefore not a waste of his time or money, he invests his initial energy in a two-dimensional painting and a small three-dimensional paper mock-up before proceeding to the actual construction.

Transfer an Image

James DePietro's procedure is to meticulously work out his entire image before applying paint to his canvas. In a preliminary step, he structures his composition on tissue paper. Elements are sketched, erased, taped in or torn out depending upon how they add to or detract from the overall image he wants to represent. When he is satisfied with this collage, he darkens the back side with graphite and transfers his labor onto his canvas. His procedure, like Betts's and Cerulli's, is time well spent toward the attainment of the envisioned piece.

Preliminary Painting, 52" × 40"

Three-Dimensional Model, 10" × 8"

Real and Implied Depth
David Cerulli
Mixed mediums construction
52" × 40" × 8"

Building on a Strong Foundation

Cerulli conserves time, energy and money by first planning the design in two dimensions (top left). Then he works the kinks out of the envisioned structure with a three-dimensional scale model (top right). Although the finished work changes as it proceeds, these beginning steps provide a strong foundation on which to build.

Spontaneous Happenings

Other artists may just dive into a work with a passion and spontaneity that they want the piece to project. Patricia San Soucie starts by pouring a mix of several colors and plenty of water through tissue and rice papers. This action creates its own unique character each time, as pools of pigment and delineating edges emerge. Some control can be exerted over these results, but control is optional.

San Soucie then continues to establish her images of complexity and depth by adding subsequent layers of painted, workable acetate that build to a unified whole. Experience and intuition play a key role, as progress is somewhat determined by what has happened spontaneously in the previous layer.

Step 1
San Soucie begins by painting on paper. This will be the base for her unique layering process. A piece of clear, one-eighth inch Plexiglas is placed over the watercolor paper.

Step 2
She then continues her painting on an overlaid piece of acetate that has been prepared for watermedia. The paint adheres well and does not bead or flake. This is covered with another sheet of clear Plexiglas.

Step 3
She continues to develop the composition on another layer of acetate. A third piece of clear Plexiglas is added.

Step 4
A third piece of acetate is painted and superimposed over the existing layers, creating additional depth. Yet another piece of clear Plexiglas over this adds weight.

Finish
The finished painting is a unified, layered image with depth and complexity. Each layer is transparent so that the viewer can see it, viewing the composition as a whole, while seeing each part. San Soucie likes how the layers cast shadows down through the painting as well as give it weight.

Of Green Cheese and More, Patricia San Soucie, Watercolor and gouache, 14″ × 17″

Discovery at Every Turn

Oliver Rodums's approach is also designed to capitalize on a discovery. After he starts a new work, Rodums proceeds in what he calls "the four-way approach." Rotating the canvas a quarter turn at a time, he considers what has developed and continues adding form. Working on all four sides simultaneously, he sees things in new ways, and discovers new shapes, meanings and exciting opportunities. For the finish, he locks into one direction and pulls everything together.

Step 1. Rotate ¼ turn to the right from correct upright orientation

Step 2. Rotate ½ turn to the right from correct upright orientation

Step 3. Rotate ¾ turn to the right from correct upright orientation

Terrain
Oliver Rodums
Oil, 13″ × 12″

The Four-Way Approach
After making an initial start with some defined form, Rodums rotates a painting by quarter turns to all four outside edges. As he senses that the painting is reaching its conclusion, he locks into one direction and completes the work with the remaining finishing touches.

THE TOTAL PACKAGE

Careful consideration of every aspect of a painting, from deciding on canvas size and shape to wrapping up the finished piece in an appropriate frame, is necessary to fully articulate your artistic voice. In working to express that voice, no one approach is better than another. Style is a personal thing. Variety of expression is wonderful and is not dependent upon specific rules. The concept of free spech applies to the visual arts. Any stylistic credo as well as any subject is valid. The important thing is the finished product. Is the painting unified as a whole? Does it communicate your point of view? This is what should be judged.

SOME THOUGHTS ON ARTISTIC TOLERANCE

I once thought that the poet John Donne was wrong when he said that no man is an island. From my perspective as an artist, I was sure that we are all islands unto ourselves. We touch a brush to canvas and our marks reveal the soul of a singular entity. This should be cause for celebration. This isolation makes us explore our personal potential. It makes art continually exciting and new. But there are some dangers, I've found, with a strictly isolationist viewpoint.

First and foremost is intolerance. We must give thoughtful consideration to artists who express views divergent from our own. As we sit in front of our easel, illustrating our particular vision, it's important to remember that each of us is one artist among many. We know that our way of seeing is not the only way of seeing. But as we concentrate on how to share our reaction to the human condition, we may lose sight of that fact. Our art is a wonderful vehicle for af-

Making an Intimate Statement
Artistic expressions come in all shapes and sizes. For Conneen, miniatures allow her to make an intimate statement that beckons the viewer closer.

The Language of Herbs II (Handmade book), Jane Conneen, Etching and watercolor, 1¾" × 1⅝"

Making a Huge Statement
The dimensions of this work are in feet rather than inches. It encompasses the viewer in a wall of sensation. This scale expresses a passion and zest for life and art.

Untitled, Michael Kessler, Acrylic and wood, 6½' × 12'

firming our being, but a full range of other artistic philosophies exists around us.

Just as artistic respect demands that *our* own voice be heard, so too should we consider the voices of others. This doesn't mean that we have to like everyone's work or be influenced by it, but it does mean that we have to acknowledge its existence, give it a critical look, and make the effort to find out what it's trying to say. It's all too easy to build an aesthetic cocoon around our sensibilities. And there are two problems with that.

First, if no ideas can penetrate the cocoon, we use up whatever artistic fuel we have. We're left crank-ing out sterile artwork, one inbred piece after another. Our source of inspiration dries up.

Second, when we dismiss another's work outright, purely on the basis of subject or technique, we diminish the life and experience of its creator. Each is an expression of the other. And anything that diminishes the individual also diminishes humanity. This kind of intolerance is most unproductive.

A Broadened Perspective

In an ideal state all artists' work would be viewed and considered by others. This would connect us. We all judge art against our own experience, but by working to under-stand the visual ideas of others, we could envision *new* worlds and *new* personal potentials. In this way, we could broaden and clarify our own views. This, I believe, is the world Donne envisioned.

To capture your view of the universe, especially since your view is continually evolving, you must be receptive to the new. It's the key to greater self-expression. The next time the artist within says, "I dislike paintings that are unlike my own," think again. Underneath the surface of these works might lie the seed for your next important breakthrough as an artist.

Choosing a Format
Bagby enjoys working in a round format because it lets her zero in on her subject and cut off the empty corners. Choices of this type all fall within the realm of freedom of artistic voice.

Blue and White Chair
Anne Bagby
Watercolor
19" × 19"

A Gallery of Artistic Voices

A great deal can be learned by looking at the work of fellow artists. You have seen the tremendous scope, the unlimited range, an artistic voice can have. You have looked at the vocabulary of the art basics, such as line, value, color and design, and have seen how these elements can be used to enhance a point of view. All of this information is synthesized in the hands of dedicated masters. In this way an artistic voice achieves fluent expression.

Such is the case with the artists whose work illustrates this book. Their experiences, their emotions and their insights mold their unique voices into messages that evoke responses in all of us. To contemplate this art is an education of the highest order.

Anne Bagby builds images with a variety of tools—stencils, ruling pens, squeeze bottles, dip pens, bamboo pens, toothbrushes, makeup applicators, decorators' texturing tools, palette knives, tape, masking fluid, colored pencils, and the occasional paintbrush—to establish a rich patina. As seen here, she does not represent the objects as they really are, but rather as she feels about them. The decorative aspect is achieved not only in the construction of the surface but also through the flattening and simplifying of joined objects before an exquisitely patterned backdrop.

Forced Spring, Anne Bagby, Acrylic, 36" × 24"

PAINTING SUNLIGHT, SHADOW AND MAGICAL SHAPES

Visions of sun-filled days express the positive, hopeful attitude of Judi Betts. Her watercolor painting *True Love* is a moment bathed in colors that project an inviting warm glow. While the focus of the painting is tightly drawn to the symbolic chairs, her genteel world expands out of the picture plane through the use of the architecture and the important shadows it casts. The unifying design of the background foliage purposely echoes the fractured, staccato form of the chairs.

What Betts calls her "magical shapes"—unique flickers of color—move our eyes across this radiant tapestry, as they dance and rock through a sparkling atmosphere.

True Love, Judi Betts
Watercolor, 22" × 30"
Collection of Mr. and Mrs. George Mumfrey

EXPRESSING A SUBJECT IN A THREE-DIMENSIONAL SYMBOLIC DESIGN

In *One for the Indian*, David Cerulli creates a tribute to Native Americans. This three-dimensional construction of wood, canvas, paint, plastic and wire expresses his homage through symbolic design. Large arrowhead shapes are used in the four corners. Curved into facing bow shapes, acrylic plastic sheets incorporate wire that rhythmically repeats the arrowhead design, while acrylic tubing is placed between each bow as an arrow symbol.

The color range is in earth tones with small specks of turquoise. And a painted design that runs between the arrowhead tips symbolizes inlaid bone and bead work. Finally, the large open areas where the wall shows through suggest the open plains.

One for the Indian, David Cerulli
Mixed mediums, 48" × 53" × 3½"

Michigan Farm, Jane Conneen, Etching and watercolor, 2½" × 3"

CAPTURING RURAL DETAIL IN MINIATURE

A love of the countryside finds a unique form of expression in the miniature hand-painted etchings of Jane Conneen. Within an extremely compressed space, an intimate portrait of agrarian life unfolds in a densely detailed rendering usually associated with works of a much grander scale.

In *Michigan Farm*, sunny golden hillsides, blue skies and lush white clouds mirror the artist's feelings, all within the space of a few inches. The intense colors and strong value contrasts are typical of Conneen's miniatures. This intensity allows the viewer to stand close enough to enjoy the art without blurring.

EMPHASIS THROUGH MULTIPLE CONTRAST

From the most obvious interplay of light and dark to the subtle interaction of reflected abstract pattern on highly realistic tiles, Daniel E. Greene's painting is an expertly crafted study in counterpoint. Beginning with the focus of the mosaics themselves, he uses their irregular construction as a foil for the rigid uniformity of the tile walls. The tight mechanical rendering of the tile is countered with the loose visible brushwork used to capture the texture of the soot- and footprint-covered floor.

The mood of the piece is also expressed through contrast, as the heavy, ominous, solitary lighting of the underground draws a comparison to the illuminated and ethereal exit area. On a more symbolic level, the ideal beauty of urban adornment finds its antithesis in the truthful portrayal of the grit and grime of the city.

86th Street Station, Daniel E. Greene
Oil, 60" × 40"
Collection of Dr. and Mrs. J. Kevin Lynch

RE-CREATING WHAT HAS BEEN SEEN

Many artists don't choose to reproduce reality; instead, they re-create it. This is the case with Frank Webb. Beginning with what *is*, he proceeds to re-create a vision of what he feels *ought* to be.

For *Hyannis Harbor*, he scouted the seaside, analyzing the environmental makeup and making several sketches. This movement around the area helped him select the most salient silhouette. It also helped him decide what was insignificant. The finished interpretation, completed in his studio a few weeks later, is a composite of the preliminary sketches with multiple adjustments of value, placement, proportion and color all designed to enhance the aesthetic content of the piece.

Hyannis Harbor, Frank Webb
Watercolor, 22" × 30"

A VISUAL DIARY OF THOUGHTS

Expressing a personal message has always been the purpose of James DePietro's art. He considers his role as an artist to be that of a visual storyteller. His painting *Life Before Death* uses a diptych format to tell its story. These multiple picture planes contrast an expression of growth, prosperity and life with its antithesis—decline and death. The close proximity of the two images forces the viewer to connect the opposing themes into one complete idea. DePietro's palette enhances his perspective as we read from the warm, youthful green of spring on the left to the dry, conservative neutral browns of harvest on the right.

Life Before Death, James DePietro
Oil on paper, 18″×36″

Seacoast, Richard Hamwi, Watercolor, ink and cut paper collage, 24″×32″

ABSTRACT INSPIRATIONS DRAWN IN PAPER

Themes derived from nature and art are the starting point for the abstract designs and patterns of Richard Hamwi. The relationships among shape, tone and color combine to express his thoughts and feelings about landscapes, architecture, music and poetry. In *Seacoast*, his interest in capturing the rhythmic beauty and force of tides plays out in a dancing feast of jewel-like colors and high action lines.

Twelve overlapping layers of prepainted watercolor paper were necessary to achieve the depth, movement and texture that Hamwi felt the subject demanded.

Calligraphy, Charlene Engel
Watercolor, 22" × 30"

AN ECONOMY OF IMAGE

This delicate painting is a wonderful example of expression through minimal image. The fewest number of marks combine to create the bare essence of a place. Charlene Engel is not merely copying the nature she sees before her; she is painting in a way that comments on the landscape, her thoughts about it and her memories of it. She achieves an inviting simplicity drawn in liquid color. Every stroke is independent and articulate as in calligraphy. Once told that the mathematical meaning of elegance is the simplest answer, Engel tries to include only what she needs in a painting.

Stars and Stripes
William Persa
Watercolor
30" × 20"

AN EXPRESSION OF PATRIOTISM

Stars and Stripes is the second in a series of works by Bill Persa that use the symbol of American freedom as their centerpiece. Inspired by the colors, shapes, and the wonderful light and dark value relationships of the flag's folds, he finds it a perfect subject for his compositions.

His goal for these works is to make the viewer feel the three-dimensionality as much as possible. For Persa, the key to achieving this response is a strong base drawing. Then building up the image with highly diluted watercolor glazes, he works toward deep color and a balance of light versus shadow.

Persian Vase
Richard Pionk
Pastel, 24" × 19"

DELIGHTFUL ELEGANCE

Creating elegant images to delight the viewer is Richard Pionk's primary artistic goal. He is also concerned with the fundamental relationship of light and dark—of light coming out of darkness. If a Persian vase in the proper light triggers this sensibility, he will compose a setup and share his reaction.

In this work, he established a classical still life with dramatic illumination that emphasizes the focal point but recedes into a rich background. The firecracker brilliance of the flowers against this dark foil further demonstrates the impact that light and color can have.

STEPPING INTO A LANDSCAPE

A few years ago, Scott Field was working on a series of purely academic landscapes, honing his skills in drawing and observing. He chose to portray desolate areas or barren courtyards, because he felt these subjects invited viewers to put themselves in that moment, that place and that time.

In this piece, our eyes walk around the tree and lamppost into the quiet middle ground. We respond just as Field planned. Developed from light and middle tones to dark values and black, the beauty of this drawing is in its subtle touch and soft contrast.

Untitled, Scott R. Field, Charcoal, 16" × 20"

SYMBOLS OF AN ANCIENT PEOPLE

In an ongoing series of works dedicated to the edifices of ancient civilizations, William D. Gorman conjures up an image of a bygone age. *Newgrange Series: 7 Megaliths* combines the magic of imagination and images derived from physical artifacts. This beautifully composed painting lets us see the carved detail as well as feel the dramatic effect of these huge megaliths. Gorman uses stone inscriptions, landscape, sky and other Irish decorative motifs to create a sense of place, time and spiritual experience.

Newgrange Series: 7 Megaliths, William D. Gorman, Casein, 22" × 30"

COMPRESSING THE ACTIVITY

In Irwin Greenberg's *St. Germaine Nocturne*, Parisian buildings silhouetted against the night sky provide a sort of stage set behind the sharply contrasting thin sliver of yellow light in the cafe. This narrow band filled with people, activity and energy provides the inner life of this painting. As Greenberg puts it, "Not much happening in most of the picture, but a lot happening in a small part of it."

We are pulled across the foreground toward this brilliant illumination and into the excitement that we know awaits us in the city of light.

St. Germaine Nocturne, Irwin Greenberg
Watercolor, 11″ × 14″

SEEING EXCITING COLOR IN NATURE

Painting the natural world and its exciting colors has been satisfying enough for Edith Roeder, but now, as she watches these places disappear, engulfed by housing developments and shopping malls, the subject seems to be making a social statement about preservation as well.

In *Thaw on Lizard Creek*, she focuses on the compositional play of action and calm, and the contrast between the creek's dark winter water and the stark white snow. The oil was applied in one quick layer over an acrylic underpainting. Roeder used a palette knife application technique to keep the brilliant color unmuddied.

Thaw on Lizard Creek, Edith M. Roeder
Oil, 16" × 20"

Swallowtail Survey
Priscilla Taylor
Rosenberger
Watercolor
19″ × 14½″

AN AESTHETIC STATEMENT IN CONSTRUCTED STILL LIFES

Contemplating the aesthetic quality of objects rather than their utilitarian purpose is often the starting point for Priscilla Rosenberger's still-life compositions. The contrasts of textures, surface qualities, colors, edges, and natural versus man-made objects unite in an arrangement that she finds visually pleasing. In this painting, the strong directional lines of the cloth, box, leaf veins and napkin ring converge at a point beyond the hovering butterfly, increasing the feeling of depth and heightening the sense of the swallowtail's flight. The end result is an arresting visual arrangement that reflects a sense of balance, peacefulness and beauty.

119

A PERSONAL EXPRESSION OF A WIDELY SHARED EXPERIENCE

This thoughtful self-portrait is a work in progress that has transpired over many years. Beginning with the central nude figure, Barbara Kacicek establishes an image of a woman carrying life within her. It is not, she says, a version of the Annunciation in the traditional biblical sense, but rather her expression of the immensity of the moment when the responsibility for bringing a being onto this earth is understood. This work of art speaks of a moment that is both extremely personal and widely shared at the same time.

Annunciation: A Time of Flowers
Barbara Kacicek, Charcoal, 19" × 23½"

Untitled, Michael Kessler, Acrylic, 6½' × 12'

PULLING THE ENVIRONMENT INTO A PAINTING

Exploring combinations of color, space and architecture has led Michael Kessler to an artistic philosophy of creating an environment friendly to a painting. Beginning by spilling paint onto the picture frame, he now takes his brushwork into the artwork's environment.

In a sense, Kessler is expressing his desire to paint the whole world. In this example, the optic vibration of the complementary color scheme creates a visual massage for the viewer. The huge scale of this painting works with the carefully designed hue and texture of the wall to envelop us in a world of pure sensation.

White Door
Earl Grenville
Killeen
Watercolor
21" × 16"

SYMBOLIC IMAGES

We have all opened, closed, walked through, passed by and been locked outside of countless doors. This is part of the human condition expressed in this painting by Earl Killeen, who finds great beauty in the everyday, mundane objects around us. Specifically, *White Door* draws on strong memories of early childhood and the double-hinged garage doors of his grandparents' home.

Killeen also speaks of the symbolic aspect of his locked door paintings. In the early 1980s he found himself knocking on the closed doors of galleries that would not open for him. Ironically, it was the resulting door series that opened up those art world voices.

CAPTURING A FEELING

A word triggers a visual image that becomes a work of art through the hand of Katherine Chang Liu. Her mixed mediums canvas *Palimpsest* is just such an expression. The word *palimpsest* comes from the Greek language and refers to old writings on parchment that have been erased by time, with new writings added on top. The vivid colors and strong gestural texture in Liu's painting evoke the feelings these objects inspire. As a master of subtle balance, of giving the viewer just enough information to spark their imaginations, Liu shares an image of essential sensation that invites reaction and participation.

Palimpsest, Katherine Chang Liu
Acrylic and drawing tools, 39" × 25"
Courtesy of Louis Newman Galleries

A RECORD OF EVERYDAY LIFE

The awesome beauty of the land around his northern California home has been a constant source of artistic inspiration for Jim McVicker. *On the River* is just such a personal statement. The light, shapes, reflective quality of the water, and natural order all express what has touched him emotionally.

Working directly in a classic plein air approach, he sets up his canvas and supplies on the spot and works quickly to capture as much of the image as possible before the light changes. He returns to this same location from fifteen to twenty-five times, or more, building his image until the desired realistic declaration is achieved.

On the River, Jim McVicker, Oil, 30″ × 78″

EXPRESSING A SPIRITUAL HARMONY WITH NATURE

The uplifting feeling Midge Stires experiences when surveying vistas from a high lookout is inspiration for her landscape paintings. The higher the viewpoint, the more unobstructed the scene. In this elevated atmosphere, pleasant sweeps of rolling hills and long open views unfurl into panoramas of color, light and shape that are almost abstract in their expansiveness. Stires prefers to paint the entire scene on the spot. The actual dimensions of her finished pieces are not large; many are as small as 4″ × 6″. Their overall impression, however, absorbs the viewer in their scope.

Bowers Field, Midge Stires
Acrylic, 20″ × 30″

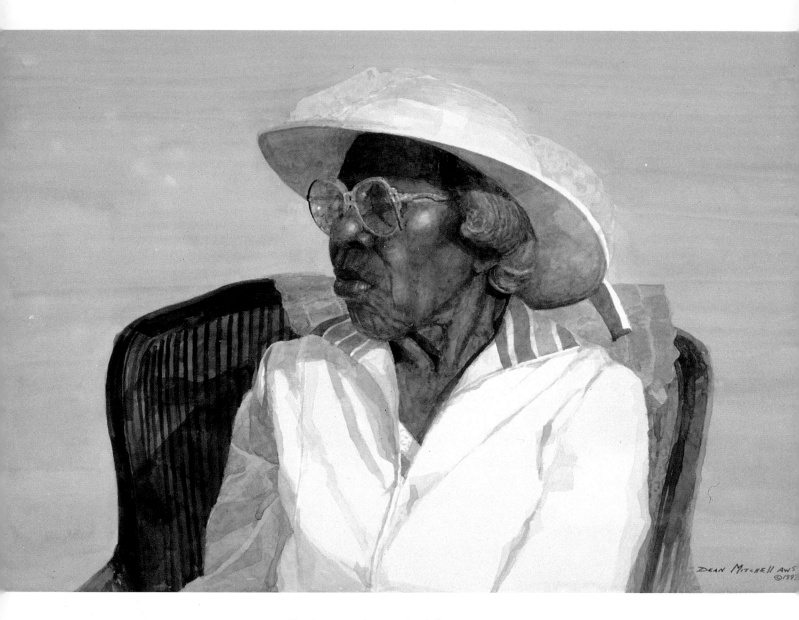

CAPTURING AN INDIVIDUAL'S CHARACTER

Dean Mitchell's portrait of Rowena, a nonagenarian member of his church, captures the spirituality and dignity of a woman who has lived through an age of tremendous change. *Ready for Church* is just one of his respectful depictions of her heroic character.

Mitchell also found a theme in the historical record of the unique hats many African-American women have traditionally worn to church. Celebrating and sharing the African-American experience through his painting is central to Mitchell's artistic expression. One of his primary goals is to work toward a more accurate balance of African-Americans' representations in art museums.

Ready for Church, Dean Mitchell
Watercolor, 15" × 20"

CONCEPTUALIZING THE ELEMENTS OF A COMPOSITION

All of Scott Moore's work draws upon childhood experiences. This painting addresses the intrigue that this particular product provided while he was growing up. The word "pet" had always meant "dog" in his home, so a dog house on top of the can of milk seemed appropriate. Although the pet here is a cow, Moore has provided it with its dog bowl, chew bone and rubber ball. When designing the background, he remembered contemplating how dogs who slept outdoors might think about dogs who lived indoors. This led to comparable thoughts about cows. Hence the moonlit hillside with this lucky bovine's friends, the ones who live outdoors, going about their business.

The surreal night scene relies on the light source of the moon to create its special "moooood."

Pet Milk at Night, Scott Moore
Watercolor, 16" × 18"

HAND-STITCHING A PAINTING

Patricia San Soucie's designs recall the decorative pattern of hand-stitched quilts. By interweaving lines, shapes and colors, she "sews" together an image. In this painting, her sense of fun asks the question, What if Granny Albers crocheted while Josef painted? Here, in loose knots of paint, rough edges and squiggley lines, we see San Soucie's interpretation of Granny's interpretation of artist Josef Albers' artistic voice. Each one is doing his or her own thing.

Granny Albers' Crocheted Square
Patricia San Soucie
Watercolor/gouache, 35" × 36"

Painting Love, Peter Schnore, Oil, 53″ × 49″

BRINGING ORDER TO CHAOS

A sense of integration and order in Peter Schnore's snowless winter forest paintings is a conscious response to an otherwise chaotic life. Here in his art is one place where continuity and an even tenor can be arranged at will. The scale and complexity of his subject are orchestrated into a striking painting of high spiritual content. Working in a controlled frenzy for the first day, Schnore employs the basic elements of art and design as a subconscious support for his spiritual expression. His subsequent work is slower, as he brings the whole composition together into an illustration of his love of order, art and artistry.

SMALL WORLDS WITHIN A LARGER WORLD

This painting is an example of my pointillistic approach. I break down what I see into dots—the simplest building blocks—and then reconstruct them.

In this particular piece, my intent was to show a group of unrelated individuals strolling through a beautiful, ethereal landscape. Participants moving in their own space are often unaware of the events and people around them. Sometimes they come together, sometimes they cross paths, but sometimes they don't. My purpose was to capture this idea of many small, private worlds within the larger world we all share. Expressions of love, passion, companionship, family, humor, absorbed interest, even the loneliness that age can bring are all part of this split second of frozen time.

A Day at the Races, David P. Richards
Watercolor, 24½" × 40"

SHARING INTIMACY

David Reinbold's drawing is a meticulously rendered expression of love. In this work he combines all the subjects for which he feels an affinity: his wife, home, environmental landscape, a still life, draped material and the ever present subjects of light and air.

Composed in a classical layout of foreground, middle ground and background, the image leads us from the entry way of the chair angles into the material, around the figure, and through the window to the landscape. All the while we remain in a quiet environment gently encased in air and bathed in sunlight.

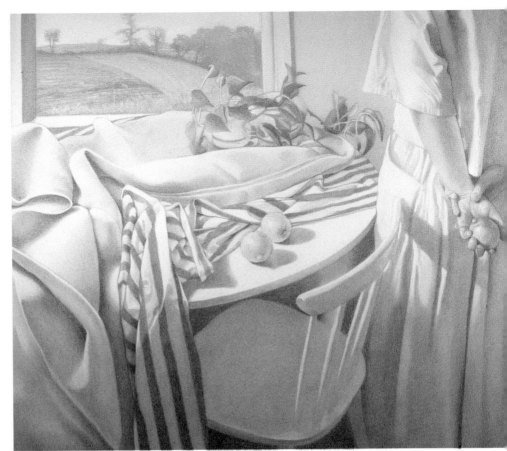

Three Lemons, David Reinbold
Conté, 28" × 35"

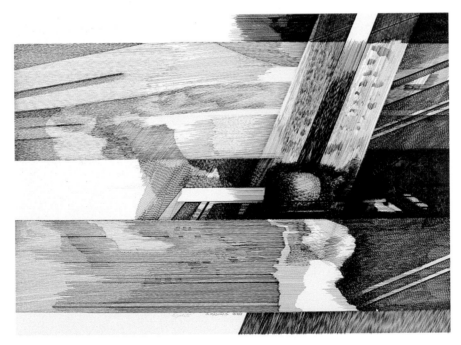

Egalite, Oliver Rodums
Ink on paper, 23" × 29"

PAINTING A PASSAGE OF TIME

The passage of time has been a recurring theme in the paintings and drawings of Oliver Rodums. Time is flux; time is speeding on; time is constant change; and time is changing shapes and forms in its passing. With no clear image of how the finished art will look when done, Rodums lets it grow as he goes. Spontaneously, changes happen, risks are taken.

In *Egalite*, lines of rich black and soft subtle color are laid in free hand or with a ruler in rapid parallel strokes, building up a collection of loose and tight shapes that reflect Rodums's inner space, flowing movement, and his superb sense of time.

SPEAKING BODY LANGUAGE

This beautiful composition of figures in repose captures the heavy weight of warm bodies stretched out and relaxing in the midsummer sun. Serge Hollerbach captures this moment in a way that transcends the anecdotal or illustrative and achieves an expression of the human condition in general. He arranges the bodies in a way that fills up the entire picture plane. A strong design base of diagonals and a horizontal combine with sharp angles to pull us into and through this picture. The contrasting complementary green base further heightens the effect of the pale pink fleshtones. And the rest, as they say, is body language.

Sunbathers, Serge Hollerbach
Acrylic, 40" × 20"

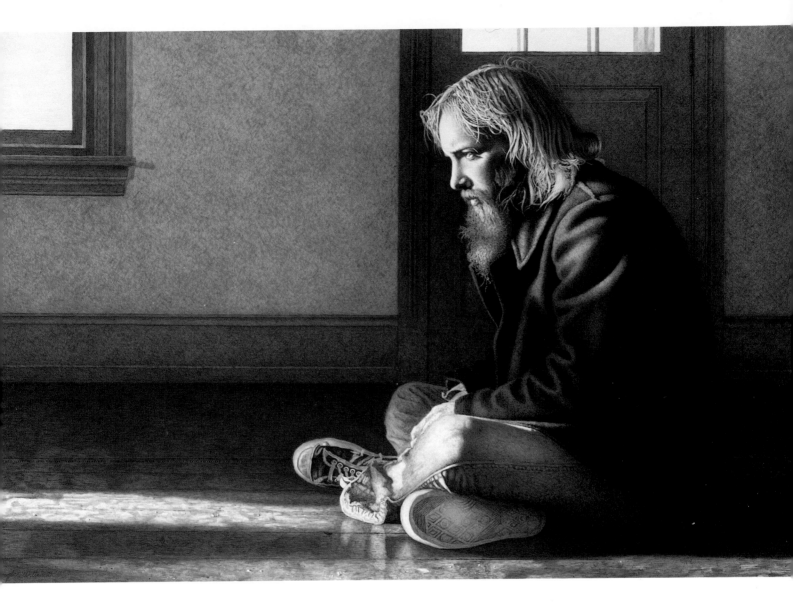

CAPTURING THE POIGNANCY OF A MOMENT

As we have seen, there are countless reasons for an artist to choose to paint a particular subject. Douglas Wiltraut's painting *Mourning Dove* is a portrait of the painter's brother in a time of sadness as he mourns the loss of a friend. This personal tragedy was compounded, as it coincided with the murder of John Lennon. For Wiltraut, this frozen image of a lone figure mourning in the late afternoon sunlight seemed to represent how everyone in the world felt about senseless tragedy. Focusing a solitary beam of light on the subject, the artist gives the portrait warmth and appeal even in its sorrow. It is a thoughtful statement about a moment that is individual, private and poignant, yet one that can be universally appreciated.

Mourning Dove, Douglas Wiltraut
Acrylic, 28" × 42"

Moving On

"Whatever you are is never enough. You must find a way to add something, however small, from the other to make you whole and to save you from the mortal sin of righteousness and extremism."

— Chinua Achebe

None of us functions in a world untouched by others. We live in the company of all of the influences and experiences that have crossed our path. Acknowledge the importance of these contributions. Be open-minded to the voice of all. These dispositions move us forward.

Recently my artwork underwent some substantial changes. For some time I had been moving away from the figurative images of peaceful landscapes and quiet cityscapes toward a more intense questioning of the structures of life that surround us. I wanted to convey how I perceive the very anatomy of matter, the particles and waves that make up the universe. I struggled with how I could best portray these structures, knowing it required tremendous change. And change doesn't happen overnight. I concentrated on this new work and did a few small drawings and paintings toward that goal, but for the most part, I continued to work as I always had. My paintings were not addressing what I wanted to explore and express.

At about this time I attended an exhibit that covered fifty years of American art. As I stood before each painting, I couldn't help thinking about my emerging concept. It was a perfect combination — the right time, the right place and the right state of mind. The abstract and non-objective collections were at the center of this revelation. I viewed and I understood. The works of Diebenkorn, Rothko, Goldstein, Martin and others all made their mark. On that day my new direction became clearer.

Leaving the familiar and comfortable behind was not easy, but the need to express my artistic voice convinced me to persevere. To capture ongoing experiences, we must be receptive to the new. It may one day be the key to greater artistic self-expression. Without taking something from the "other," I could never have begun the journey I've started.

An artistic voice — like any living thing — evolves constantly. Encourage this adaptation and change. Your work will then be an accurate reflection of who you are. Paint what you believe in. Venture into the unknown to discover what is of personal importance. When you feel it, you'll know it. When you see it, express it.

Your journey will amaze you. And as you move forward, you may take a wrong path. You may need to turn around and try another. But take that first step. Choose a path. One path will lead to another and another and another. The finish line is always connected to the starting point by the decisions made along the way. As you look back, you will see the extension, the portrait, the artist you are.

"Give us more to see."

As an extension of my particular articulation of the world around me, I have become increasingly interested in what lies beyond what the naked eye can perceive. For me, the dots of pointillism are symbolic of the atomic level of matter. But what represents the subatomic level? This is a question I will explore as I "move on" with my art.

Ceci n'est pas une pipe, too
David P. Richards
Acrylic, 20½" × 18½"

These acrylic glazings are my interpretation of time, space, energy, waves and particles. This is an unseen yet very real world. In what could be considered an almost complete contrast of style, subject and mood to my pointillistic paintings, these nonobjective works afford me the full opportunity to explore my world and express my artistic voice.

The Construction of Matter
David P. Richards
Acrylic, 22½" × 21½"

INDEX

A complete catalog of North Light Books is available FREE by writing to the
address shown below, or by calling toll-free 1-800-289-0963. To order additional
copies of this book, send in retail price of the book plus $3.50 postage and handling
for one book, and $1.00 for each additional book. Ohio residents add 5½% sales
tax. Allow 30 days for delivery.

North Light Books
1507 Dana Avenue
Cincinnati, Ohio 45207

Stock is limited on some titles; prices subject to change without notice.

Write to the above address for information on North Light Book Club, Graphic
Artist's Book Club, *The Artist's Magazine*, *Decorative Artist's Workbook*, *HOW* maga-
zine, and North Light Art School.